HOW TO PHOTOGRAPH
YOUR LIFE

HOW TO PHOTOGRAPH
YOUR LIFE

NICK KELSH

Stewart, Tabori & Chang
NEW YORK

Published in 2003 by
Stewart, Tabori & Chang
A Company of La Martinière Groupe
115 West 18th Street
New York, NY 10011

Export Sales to all countries except Canada,
France, and French-speaking Switzerland:
Thames and Hudson Ltd
181A High Holborn
London WC1V 7QX
England

Canadian Distribution:
Canadian Manda Group
One Atlantic Avenue, Suite 105
Toronto, Ontario M6K 3E7
Canada

Library of Congress Cataloging-in-Publication Data
Kelsh, Nick.
 How to photograph your life / Nick Kelsh.
 p. cm.
 ISBN 1-58479-279-5
1. Photography—Amateurs' manuals.
2. Photography of families—Amateurs' manuals. I. Title.
TR146.K42 2003
771–dc21

 2002042616

The text of this book was composed in Bank Gothic
and Franklin Gothic.

Edited by Marisa Bulzone
Designed by Nancy Leonard
Graphic Production by Kim Tyner
Printed in China by Toppan Printing Ltd.

10 9 8 7 6 5 4 3 2 1
First Printing

I PHOTOGRAPHED THIS BOOK WITH
MY WIFE'S CAMERA

As one of a hundred fortunate photographers from around the world chosen to work on the book *A Day in the Life of Africa,* I was given a professional-level digital camera and a high-end amateur digital camera that fits in a jacket pocket as a backup system. When I got back from Africa I gave the small camera to my wife, Anne, and didn't think much about it until she kept asking me to show her what the camera could do. It dawned on me that the ideal way to demonstrate professional thinking to amateurs was on a level playing field—that is, with amateur equipment. You are holding the result.

This book is not intended as any kind of guide to digital photography. I refer to digital cameras and some of their disadvantages throughout this book, but the thinking applies to film cameras, too.

It's exciting to wade into the future, but mostly I'm tickled by the fact that I photographed a book with my wife's camera.

▼ CONTENTS

INTRODUCTION

I'M GOING TO PHOTOGRAPH MY LIFE IN ORDER TO HELP YOU PHOTOGRAPH YOUR LIFE. I'll use an amateur point-and-shoot camera and leave my professional gear behind. I am, however, going to apply professional thinking to these pictures. I'm going to show you what goes through my mind when I take snapshots.

How does a professional, working with amateur equipment, photograph a high school graduation? How about a black dog? What does a serious photographer with a pocket-sized camera photograph at a second-grader's birthday party? I hope you will find the answers not just interesting but useful. This doesn't mean I'm going to tell you how to think—there are a thousand ways to photograph a flower—but I am going to show you the process as I see it.

Here's why I think this will work: Several years ago I spent a week photographing the U.S. Olympic Swim Team trials. The Kelshes are a land-locked people (I was born in North Dakota) and my swimming skills have never been outstanding, so it was fascinating to watch people who were not just comfortable in a pool, but lived to be in the water.

I spent hours behind an underwater viewing window observing the specifics of their individual strokes. I never went in the pool; I just observed. Juxtaposed against the

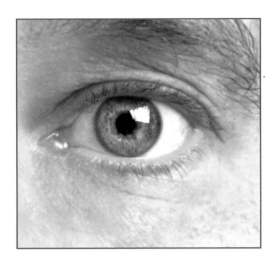

beauty of America's finest athletes I could see the inefficiency of my flailing kicks and my ludicrous breathing technique.

The next time I went swimming I was a better swimmer. I was more relaxed than I'd ever been in the water and I think that made all the difference, but I also had some insight into my mistakes. To this day, whenever I go swimming I remember the relaxed grace of great swimmers.

That's what I hope to do for you in this book—swim a few laps in the photographic pool. This probably won't turn you into an Olympic-class photographer any more than I can hope to one day lifeguard professionally, but I do believe that the simple act of reading this book will make you a better photographer.

This book is for all of you who are frustrated by the snapshots you want to treasure. It's for all of you who, over the years, have told me you are a bad photographer and yet you still love to take pictures. More significantly, it's for all of you who are open to the idea that the problem is not in the frame of your viewfinder, but in your frame of mind.

THREE SIMPLE RULES

A WILLINGNESS TO EXPERIMENT IS WHAT SEPARATES THE GOOD PHOTOGRAPHERS FROM THE NOT-SO-GOOD. Long before pros owned lots of cameras and measured exposures, photographers took pictures just to see what would happen. They were willing to see how it would "come out."

In this digital age, it comes out now, allowing us to learn technique as we shoot. What a blessing—and what fun. When you're having fun and like the results, you take pictures of more than just birthdays and anniversaries. You are always on the lookout for something else to photograph. In other words, you are photographing your life.

Be more playful with your camera. When you play with your camera, your photographic horizons expand and the limits you place on your subject matter evaporate. But even playfulness has its limits, so keep a few simple rules in mind:

1. GET CLOSER TO YOUR SUBJECTS, EITHER BY ZOOMING IN WITH YOUR LENS OR STANDING PHYSICALLY CLOSER. This will eliminate extraneous backgrounds and other distractions. Fill your frame with what you want to see and leave out the rest. Your pictures will have immediate impact and a feeling of intimacy. That sounds simple, but determining what's important and what's not is a never-ending challenge.

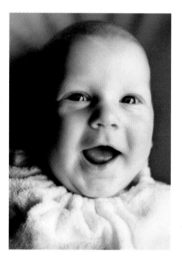
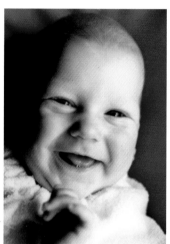
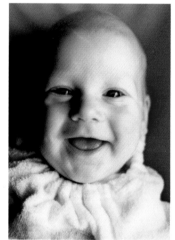
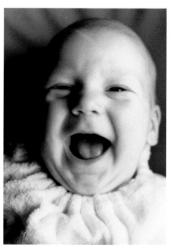

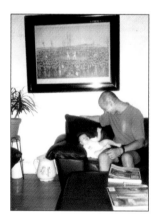

ABOVE: ONE PICTURE MIGHT BE WORTH A THOUSAND WORDS, BUT THIS SINGLE SHOT TAKEN FROM A DISTANCE SAYS NOTHING.

ABOVE: MOVE IN CLOSE AND KEEP PRESSING THE BUTTON.

2. DON'T LIMIT YOURSELF TO A FEW PICTURES OF AN IMPORTANT SITUATION. Keep pushing the button just to see what you will get. This rule is all about increasing the luck factor, and believe me, luck has a lot to do with many great photographs. With a little practice, you seem to become luckier—because you increase your odds of getting that one beautiful picture. With a digital camera there's no added cost. Then you can—and should—delete the rest of them.

3. DON'T PUT YOUR SUBJECT IN THE MIDDLE OF THE PICTURE. Keep the subject off-center. With people, that usually means to the right or the left; with landscapes, keep the horizon or point of interest above or below the center. Artists say this creates visual tension. That's just another way of saying that a subject placed in the middle of a photograph is a little boring.

The world's great museums are filled with photographs that violate these basic rules. But the photographers who shot those classics would agree that you need to understand the rules before you can successfully break them. For now, you're off to a huge head start: Anyone who loves to take pictures is a great photographer waiting to happen.

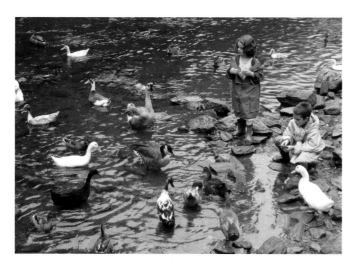

ABOVE: THE CHILDREN ARE THE SUBJECT OF THIS PHOTOGRAPH AND PLACING THEM ON THE SIDE IN THIS COMPOSITION DOESN'T CHANGE THAT FACT.

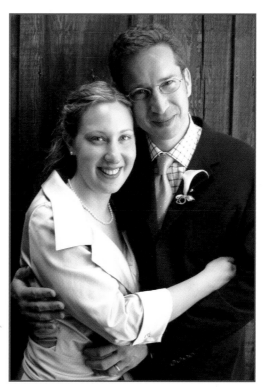

RIGHT: AS THIS PAIR OF PHOTOS SHOWS, FRAMING CAN HAVE A PROFOUND EFFECT ON EMOTIONAL IMPACT. THE VERTICAL VIEW IS MUCH MORE DYNAMIC.

CAMERA SETTINGS
AND FILM

I WILL NOW ATTEMPT THE IMPOSSIBLE: to explain *f*-stops, shutter speeds, depth of field, ISO ratings, lens coatings, auto exposure, auto focus, color correction, exposure compensation, manual exposure, manual focus, and Adobe Photoshop in two pages.

The two systems by which we measure exposure—*f*-stops and ISO—were invented by scientists who forgot to tell us what the numbers meant before they died. The numbers mean something to someone but not to you and me. They are simply relative. It would be nice if *f*-stops were numbered from one to ten, but they are not. A small *f*-stop *number* means a big *f*-stop. In other words, *f*/2 is bigger than *f*/22. I hate that.

Think of *f*-stops and shutter speeds as you would a water hose and think of light as the water in the hose. A big *f*-stop means there's a lot of water coming out of the hose; a small *f*-stop means it's a trickle. A long shutter speed means you let the hose run for a long time; a short shutter speed means you let it run for a short time. We will call a full bucket the perfect exposure. There are two ways to fill the bucket.

1. LOTS OF WATER COMES OUT FAST (BIG *F*-STOP, BIG OPENING) FOR A SHORT TIME (FAST SHUTTER SPEED, LIKE 1/100TH OF A SECOND).

2. WATER TRICKLES OUT (SMALL *F*-STOP, SMALL OPENING) FOR A LONG TIME (LONG SHUTTER SPEED, LIKE 1 SECOND).

In both cases, the exposure is the same, but they are not, sadly, the same photograph.

The reason is depth of field. Depth of field means that if you focus on a tree 20 feet away from you with a big *f*-stop (*f*/2, for example, which is a small number but a big opening and big *f*-stop) the tree that is 10 feet away and the tree that is 30 feet away will be out of focus. If you use a small *f*-stop (*f*/22, which is a big number but a small *f*-stop and a small opening) all of the trees will be in focus. Same exposure, different photographs. The one taken with the smallest lens opening (or *f*-stop) has more things in focus. Do not ask why. It's complicated. Just remember that when people squint it makes things sharper. Eyes wide open (*f*/2, big *f*-stop, big opening) means lots of stuff will be out of focus. Squinting (*f*/22, small *f*-stop, small opening) means lots of stuff will be sharp.

A film's sensitivity to light is represented by its ISO number. (ISO stands for International Standards Organization.) ISO 50 means film that is not very sensitive to light but of high image quality—not grainy. ISO 400 means film

that is very sensitive to light with slightly lower quality—a little grainy. A high ISO number means it's easier for you to take pictures. You can use faster shutter speeds, which make it easier to hold the camera still long enough to take the picture, and smaller f-stop, which means more things will be in focus. In a digital camera, the ISO settings represent a change in the light-sensitive chip that replaces film inside the camera. Increasing the ISO setting on a digital camera serves the same purpose—allowing you to use a smaller f-stop and a faster shutter speed, making it easier to take the picture—but the digital image will decrease in quality. The image will look more pixelated—often referred to as "picking up noise." The amount of deterioration varies from camera to camera. A low ISO number means you will have to pay a price for higher quality pictures, perhaps by having to use a tripod while the guy with the high ISO film does not. I recommend ISO 400 film. There are some great photographers who have made it their signature look.

Lens coatings—and good glass—are what make lenses expensive. Good lens coatings mean less flair and greater contrast—in other words, you won't get those weird white spots or pictures that don't look very snappy when you are looking into the sun. This is why you can take surprisingly sharp pictures with a reasonably inexpensive lens if the light is right. If the light is wrong, you will think you had some bad processing, but it's really your lens. Good optics are good optics. This is important whether you're shooting film or digital format.

Auto exposure is not perfect, but it's often better than exposure by humans. This is where a digital camera sings—you can check your exposure as you shoot. If your picture is dark, add (+) more exposure. If it's too light, reduce (--) the exposure. Many cameras have a plus or minus exposure compensation setting; use it, it's your friend.

Auto focus can be the enemy because it just doesn't work all the time. It's good for most snapshots, but if you want to get serious you need to understand manual focus. Estimate the distance to your subject. If it looks like 20 feet, put 20 feet into the manual focus setting. If your pictures are continually slightly out of focus, you might want to spend some time studying a tape measure.

For those of you who are transferring your photos onto your computer, Adobe Photoshop is the digital toolbox that lets you hammer and saw your pictures into whatever form you want. Pretend your picture is a piece of clay. Did you take a picture on a cloudy day that came out a little blue? No problem; Photoshop will make it a little orange for you—like the light at sunset. That's color correction. If Photoshop is so great, can it fix all of my problems, you may ask? No. It's better and easier to get it right the first time.

LIGHT AND PHOTOGRAPHY

IF I COULD GIVE YOU ONE PHOTOGRAPHIC GIFT IT WOULD BE THIS: an understanding and appreciation of the effect of light on human emotions, something most amateurs—or professionals for that matter never consider in a lifetime of snapshooting. For many of you, however, it will change how you approach everything in photography.

It all boils down to this: When you send your mother a flash picture of your daughter napping in a window seat—her reaction will probably be something like, "What a cute picture." And if you send her the same picture taken in the light that Rembrandt built a career around she may very well need to close the door, sit down, shed a few tears, and then share your photo with her friends and neighbors (all of whom will comment on what a good photographer her child is—this is just a bonus.)

THE FLASH

I cannot explain it in words any better than I can explain it in pictures. If you get the profound difference between the two pictures at right you are on your way.

The flash is a direct blast of harsh light coming straight from the camera. It's exactly what you see when the head-lights of your car hit someone in the face. The emotional opposite of light from a flash would be the dramatic warm light at sunrise or sunset. When light comes from a low angle and illuminates your subject from the side—late in the afternoon, for example—it creates a mood that enhances everything it touches. A picture of someone laughing becomes more delightful. A picture of someone crying becomes a little more painful.

Don't shoot pictures with a flash without asking yourself why you're doing so. Here are a couple of acceptable answers: "It's really dark. I have to." or "I don't care that these pictures have an amateur look." (I shoot pictures like this all the time.) But "I'm using a flash because I want this to be a beautiful picture" is oxymoronic.

Some cameras have a built-in flash that can't be turned off. If you're unlucky enough to own one of these and you want to upgrade the quality of your photographs, you should start shopping for a new camera. Otherwise, your camera's manual will give you complete instructions for turning off the flash.

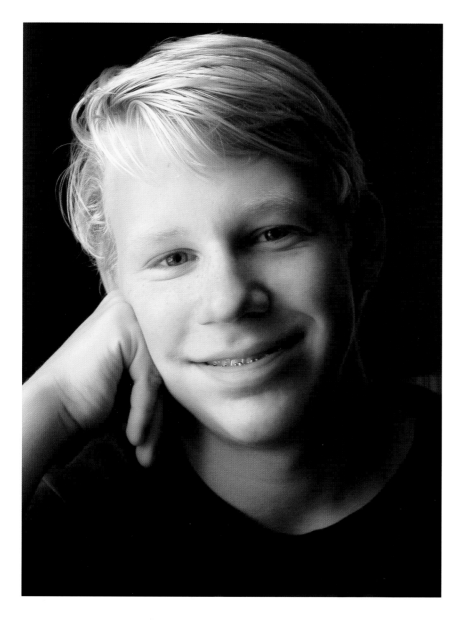

THE DIFFERENCE BETWEEN A PICTURE TAKEN WITHOUT A
FLASH (ABOVE, USING WINDOW LIGHT) AND WITH A FLASH
(RIGHT) IS BOTH SUBTLE AND PROFOUND.

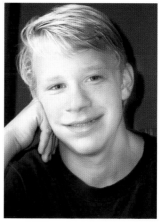

THE TIME OF DAY

Light is the photographic language of love. It allows us to transpose our feelings ónto a piece of semi-glossy photo paper or an e-mail attachment. It is actually possible to communicate to your family how you feel about them with a snapshot held to a refrigerator by a magnet.

Allow me to speak in the broadest terms about sunny days. If early mornings and late afternoons are good, then high noon is not. Overhead light is cold and unflattering, often leaving ugly shadows where eyes should be. As soon as you absorb this simple concept, you will be shooting fewer photographs in the middle of the day.

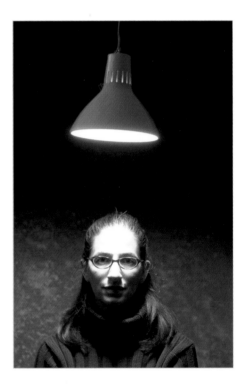

Try this experiment: The next time you're at the beach on a sunny day, shoot two consecutive frames of the same person—one at high noon and one a half hour before sunset. Change nothing but the time—same location, same clothing, same pose. Compare the two pictures side by side. They hit dramatically different emotional chords.

Experiment with natural light. Look for soft light near windows, doorways and dramatic sunlight early and late in the day. The effort you put into understanding this will pay off in a lifetime of good photography.

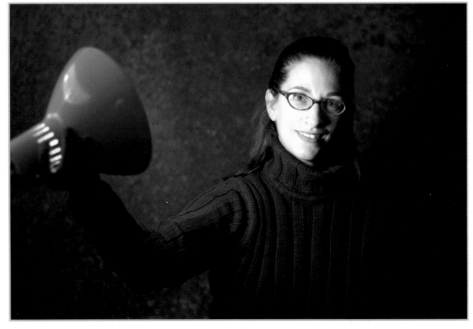

NO ONE LOOKS GOOD WITH AN OVERHEAD LIGHT SOURCE. THE SIDELIGHT IS POSITIONED LOW, MIMICKING NATURAL LIGHT WHEN THE SUN IS CLOSE TO THE HORIZON.

DO YOU NEED A TRIPOD?

The finest lenses in the world cannot conceal the fact that we can't hold still. Potential camera buyers always ask if a lens is sharp. In the twenty-first century, lenses are not the problem—but they weren't the problem in the nineteenth century, either. The problem has always been that photographers wiggle. Even expensive German optics will turn to mush in the wrong hands.

I wish I could tell you that if you buy a good tripod all of your sharpness problems will be solved, but I can't. The trick is that you must know when to use a tripod and you must know when to get rid of it. After many years, I still recall watching in frustration as a man set up a tripod to take pictures on a Florida beach on a bright, sunny day. It was all I could do to not intervene and save him from himself. I stood on the same beach later that night under a full moon and felt like a fool for having left my tripod at the hotel.

When you decide to use a tripod, you have just dropped anchor. Anchors are good—they are safe and grounding—but they are inflexible. Spontaneity goes out the window. With a tripod, your pictures will be sharper, but significant pictures will pass you by because your camera is essentially bolted to a hat rack. But if you don't use a tripod when you should, you will miss good moments because you can't hold your camera still or your subjects insist on living motion-filled lives with no consideration of your photographic needs.

Here's a simple experiment to find out if there's enough light to take sharp pictures without a tripod. First turn off your flash and turn your ISO setting up as high as you can (on my camera it's 400). Then place a newspaper page in the dim light you want to work with. The distinct edges of the headline type are a great test subject for sharpness.

Position yourself so you can hold the camera steadily. That is almost assuredly not standing upright—you may have to sit on the floor and rest your arms on your knees or lean against a chair or a doorframe. Focus carefully on the newspaper page. Before you push the shutter button, inhale and hold your breath. Then push the button slowly and softly moving only your shutter finger. Exhale only after the shutter has been released.

Examine your picture. Are the edges of the type crisp and distinct or fuzzy and blurry? If you can't take a reasonably sharp picture—it will rarely be perfect—it's time to use a tripod.

Sometimes you need one and sometimes you don't—only experience will tell you when. I love the eleven tripods that I own and I hate that I need them.

The choice to use one is yours and the decision will haunt you for as long as you take pictures.

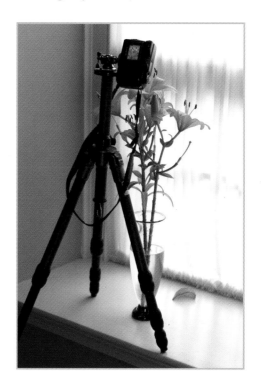

DIGITAL CAPTURE
VERSUS FILM

AMATEUR PHOTOGRAPHERS ARE TECHNICALLY CURIOUS, so I assume that if you and I happened to be driving to Alaska, at some point you would eventually ask me what kind of camera I used for this book and what kind of film I shot. The camera was a high-end amateur model (see page 5) and I didn't—shoot film, that is. This book is all digital.

Film is, and probably will be for the remainder of our lifetimes, a useful—and obviously miraculous—medium, but the digital camera is the most significant tool for amateur photographic education ever invented. There has never been a moment in history when improving your photography was more accessible than the early twenty-first century.

Right now, you can shoot more pictures faster with film, but with digital you can shoot stunning pictures in situations where film would fall on its face: fluorescent lighting, around a campfire, a sleeping baby in dim lighting. Digital images are literally electrified, which is to say they are amplified. I never cease to marvel at the image I see on my camera's viewing screen as I look at the scene itself. A digital image can often look better than reality.

That said, digital images fall apart in low-lit, shadowy situations. They become speckled with what is known as noise. Film doesn't do too well in low light either, but film gets grainy, which can actually be aesthetically pleasing. Still, if I were to shoot photographs in bad light, I would choose digital every time. I can live with the noise and I welcome the amplification. The chances of taking a picture you like are just better. All of us can use a little electronic boost.

However, I do think the cost benefits of digital photography when compared with film are greatly overrated. By the time you buy batteries and ink cartridges and printing paper, not to mention the printer itself, you are probably close to breaking even financially. But if you want to express yourself visually, if you want to make something beautiful, digital images on your home computer are going to light you up in a way that an envelope of prints from the photo processors can never touch.

I love film. There will always be a soft spot in my heart for film. I hope I live long enough to say that there will always be a soft spot in my heart for digital photography.

However, the ability to evaluate your pictures seconds after you've pushed the button can compress weeks of experimentation into an afternoon. If you decide to dedicate a Saturday to becoming a better photographer, by all means, do it with a digital camera.

Here's how it works. Look at your subject. Look at the picture of your subject. Look back at your subject. Notice how the camera reacted to the light that is right in front of you right now. Is the light soft or harsh? Is it cold or

warm? Study the results and try to improve on them now. Wow. Shoot another picture. Compare the two pictures. One looks better. Ask yourself, what made the difference? It doesn't matter if you don't know the answer. Just keep repeating this paragraph.

Shoot some test pictures under the shade of a tree. Shoot some pictures in your car. Test the limits of the camera. How dark can it be really? Take a picture of a store window at night. What was it that was wrong with that picture of your wife and mother at high noon? What exactly does a fifteenth of a second mean? Push the button and find out. Shoot pictures from a bus. Shoot pictures *on* a bus. How can you apply what you learned shooting pictures at the mall to the pictures you will shoot at the wedding this weekend?

A digital camera just lets you shoot and shoot without the worry of film costs. Keep shooting. Read your instruction manual. Reread your instruction manual. Learn how to manually focus your camera. Learn how to quickly readjust your exposures when you shoot a bad one. Don't learn things you don't need to learn, but do learn how your camera focuses; how to adjust your camera's exposure; how to turn the flash off. Get a handle on those three things. That's big stuff.

I own lots of film cameras—maybe ten altogether. I've been shooting film for thirty-five years and will likely shoot it again sometime in the future. But I think it's only fair that you know I have not shot a roll of film in over a year.

There is, however, one very important thing to keep in mind when working in the digital realm: one day, your computer hard drive is going to die. When that happens, your photographs will be lost if you have not backed them up. You have got to get your photographs off the computer and onto CDs as soon as possible. It's as simple as that.

HOW TO PHOTOGRAPH

A DAY AT THE BEACH

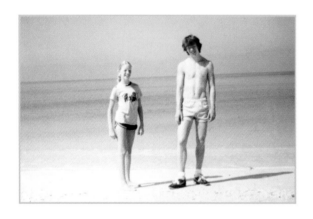

 THE BEACH AT HIGH NOON CAN PRODUCE MANY PLEASURES, BUT HAVING YOUR PICTURE TAKEN IS NOT ONE OF THEM.

THIS PICTURE WAS TAKEN AN HOUR BEFORE SUNSET, THAT MAGIC TIME BETWEEN THE AFTERNOON NAP AND TWILIGHT.

The sand is clean, the water is warm, the sun is hot, the weather is "picture perfect." So what's the problem?

The beach, despite its obvious beauty, is a harsh place to photograph people. At high noon, with the sun straight overhead, humans attempting to relax are most likely squinting or wearing sunglasses and hats. Midday sunlight is nature's version of a bare overhead light bulb.

If you want to shoot flattering photographs of your family and friends on a sunny beach in the middle of the day, put them under a beach umbrella or simply wait until later.

Here's why later is better: The sun will be much closer to the horizon, producing side light rather than overhead light. It's more dramatic.

The color of the light is much warmer late in the day, too. Midday sunlight appears a little blue, and blue light is not very people friendly. Humans just look better in warm, golden light. Photography aside, just think how different the mood at a beach is at noon and at 5:00 P.M. The good stuff happens late in the afternoon, a couple of hours before sunset, and the light has a lot to do with it.

Shoot photographs at the beach when the sun is thinking about setting and you almost can't miss. Sunrise is fine, too, but if your friends and relatives are anything like mine, they don't spend a lot of time on the beach at 5:00 A.M.

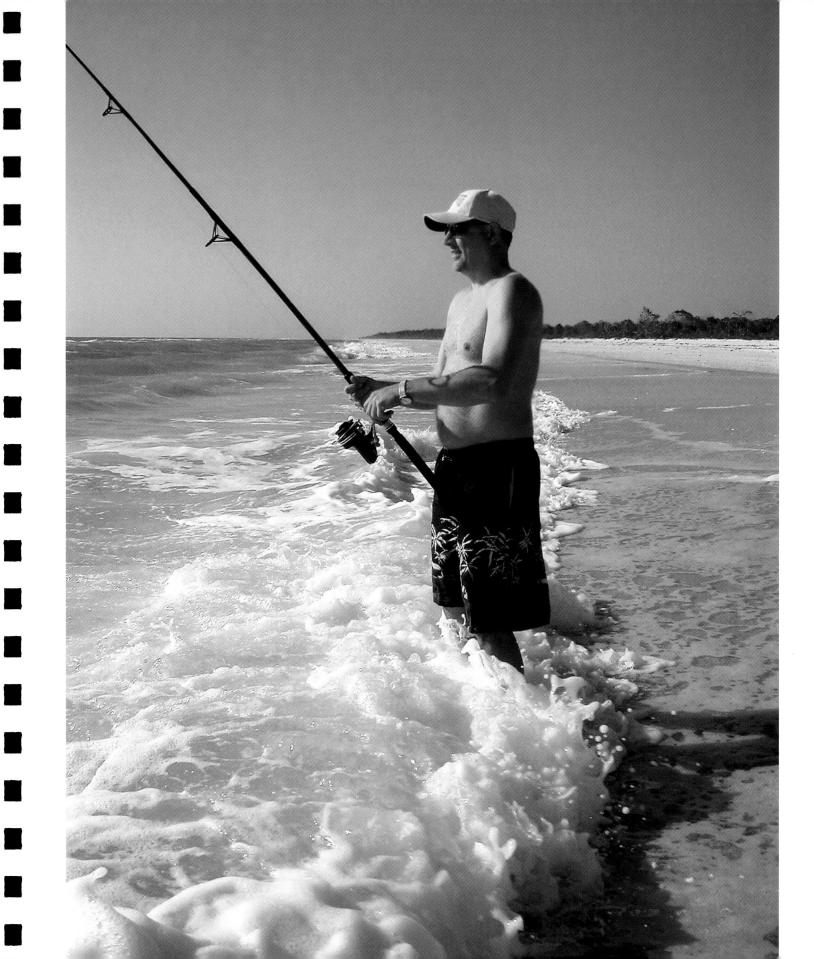

A CHILD'S BIRTHDAY PARTY

I have a picture from my sixth or seventh birthday party. Dale Brainerd is there, and Jeri Scoville, as well as some other people I lost touch with after high school and haven't seen since, but never forgot.

Everyone is sitting around a table. The light is bad (it's from the flash on my father's camera). The average head size in the 3x5-inch print is about the size of a pencil eraser. Looking back on this today, I wish I had perfectly sharp close-ups of my friends from the second grade.

You can produce a small portrait gallery of your child's friends that will one day be treasured. Pick a corner slightly away from the action, and preferably next to a bright window. Hang a bed sheet or even a piece of poster board as your backdrop—and try to get the portraits taken before the sugar from the cake and ice cream kicks in.

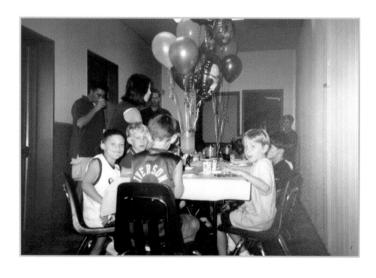

THIS PICTURE HAS BEEN TAKEN A BILLION—A TRILLION?—TIMES. I'M NOT SAYING DON'T TAKE IT, BUT WHY NOT TRY SOMETHING DIFFERENT AS WELL?

A COLLECTION OF PORTRAITS OF PARTY GUESTS IS WORTH THE EFFORT, PROVIDING KEEPSAKES FOR THE HOST AND GUESTS.

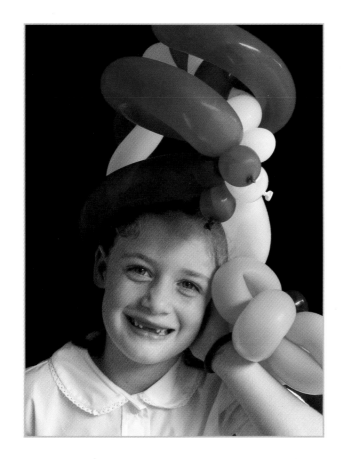
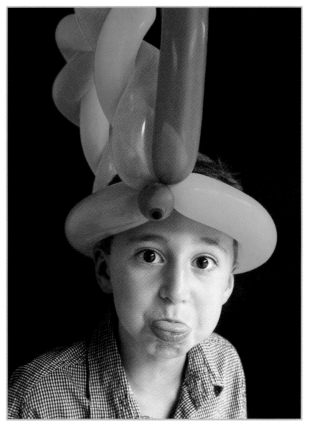
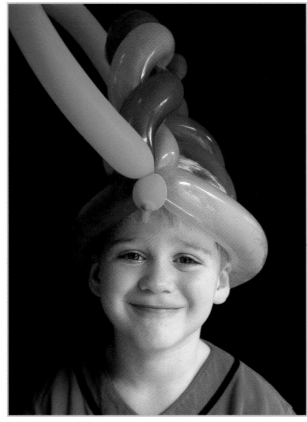
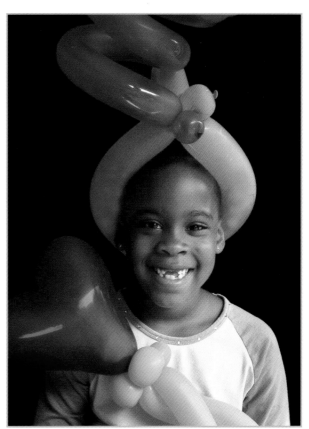

HOW TO PHOTOGRAPH
PEOPLE AROUND A TABLE

I've photographed all kinds of people around tables—not because I wanted to, but because I was faced with no better alternative. I don't remember ever choosing to pose a group of people this way.

The basic problem with the situation is that people close to the camera are blasted by the flash while people farther from the camera are left sitting in the dark. This visual inequity has never struck me as fair.

 THIS TYPICAL LOW-ANGLE SHOT MAKES IT DIFFICULT TO CAPTURE ALL THE PEOPLE AT THE TABLE.

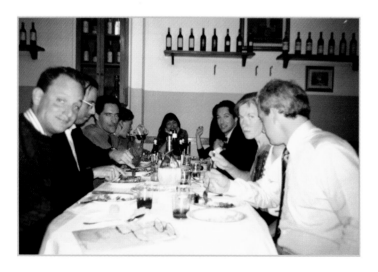

But the symbolism of everyone gathered around a bountiful, celebratory table is so obvious that my petty objections should be ignored. The situation demands to be photographed—you should take pictures of people you love sitting around tables. And the convenience of having everyone pre-gathered for a group shot—often the photographer's biggest hurdle—makes me giddy.

There are two things that will improve just about every version of this picture. Turn off the flash and shoot from a higher angle—for example, stand on a chair. This will allow you to see everyone's face and most likely much more of the table setting. Some people's heads will still be bigger than others, but there's nothing you can do about that.

In order to take the picture on the opposite page using only the lights above the table—and not the flash on the camera—I had to use a tripod. I made a big point of having everyone hold still and took several pictures just to insure that I would have one frame where everyone was sharp.

Keep the cook happy—don't let dinner get cold. With a little planning, you can take a picture quickly and efficiently and still have a record of a memorable celebration that will last for decades.

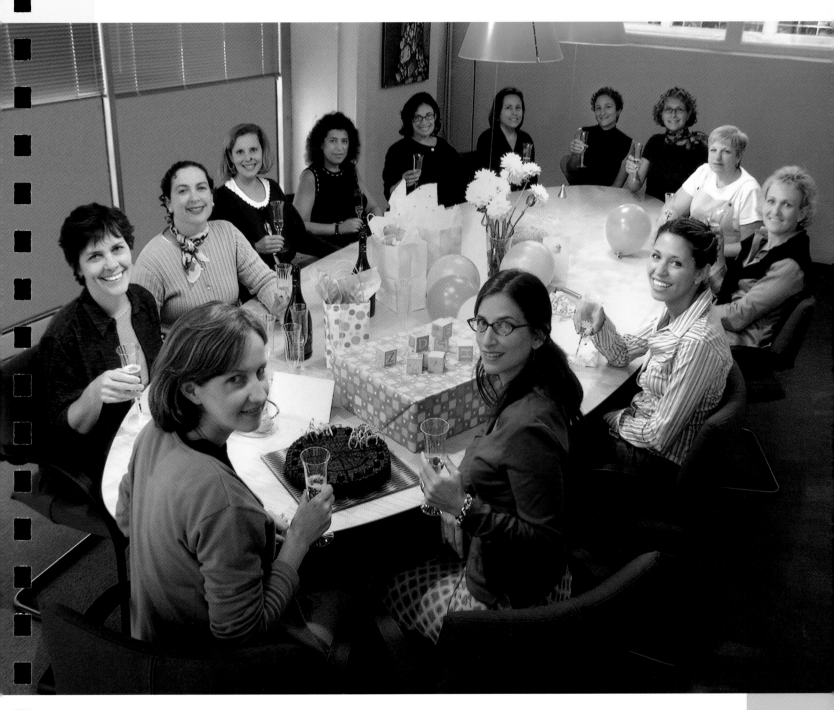

A WEDDING: THE BIG PICTURE

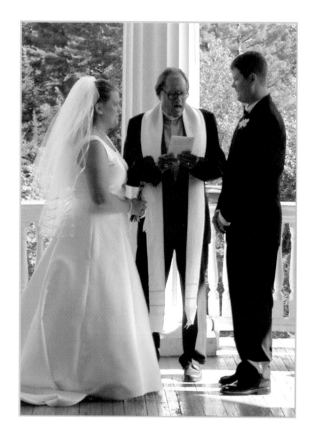

It was clear to me as I stood in the back of the space that the most important thing happening that day—a couple getting married—was already being photographed from several different angles. I could see that people were taking the close-up.

But sometimes *where* something is happening can be as important as what is happening, and I was not sure that anyone else was shooting the very important overall shot. You may find that hard to believe with a view as breathtaking as the White Mountains of New Hampshire, but in the heat of emotion it's often hard to pull your eyes and hearts away from people you love to photograph something as comparatively mundane as a location. And yet, the location carries this picture. It says, "Glorious."

One of the best pieces of photographic advice I ever heard was this: "Watch what the other photographers are doing, then do something else." It's sound advice. Do the unpredictable.

 THIS IS NICE, BUT KEEP YOUR EYES OPEN FOR THE BIG PICTURE.

IF YOU CAN CAPTURE IMPORTANT MOMENTS *AND*
THE SETTING IN THE SAME SHOT IT'S POSSIBLE
THAT YOU WILL OUTSHOOT THE PROFESSIONALS.

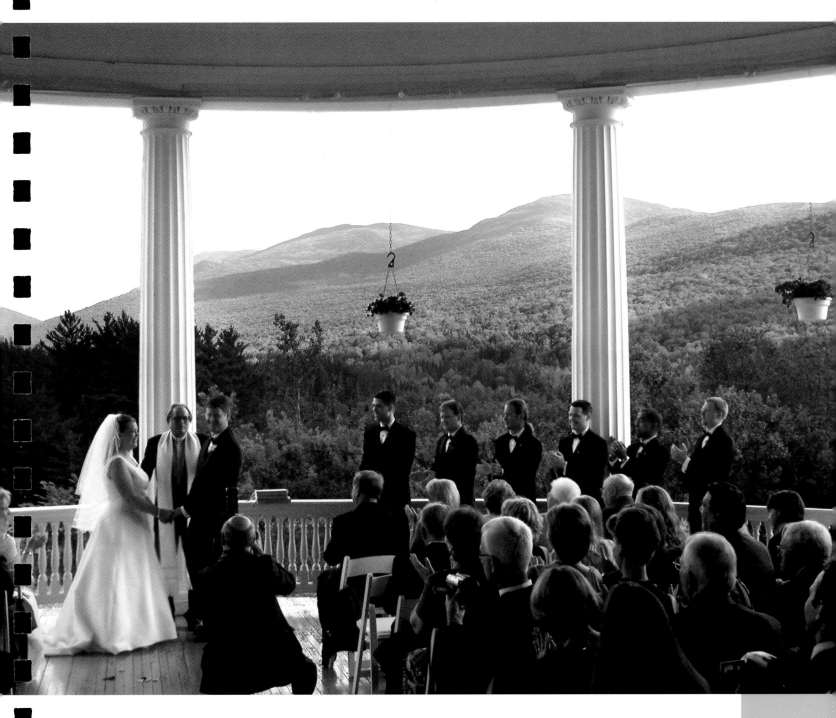

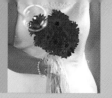

A WEDDING: THE SMALL MOMENT

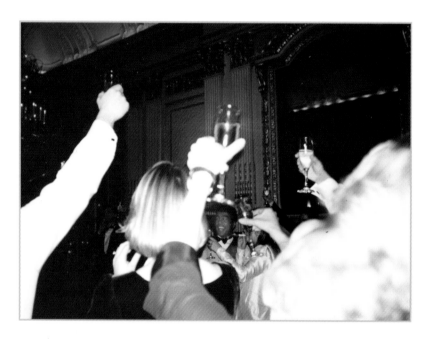

 SOMETIMES YOU LOSE...

By the time the bride and groom were getting ready to work their way down the aisle, I was standing next to four other photographers. We were all, apparently, going to take the same picture. But years of experience have told me that in situations where there is time to shoot only one or two frames, luck will decide who the best photographer is and not which photographer is trying to out-think the pack. One blink by the bride and you are out of the running.

I don't know if bad timing or unlucky bubble placement ruined many of the other photographers' pictures, but I chalk this picture up to luck. I hope the other photographers were as lucky as I was, but I've been on the receiving end of bad luck so many times it seems unlikely.

...AND SOMETIMES YOU WIN.

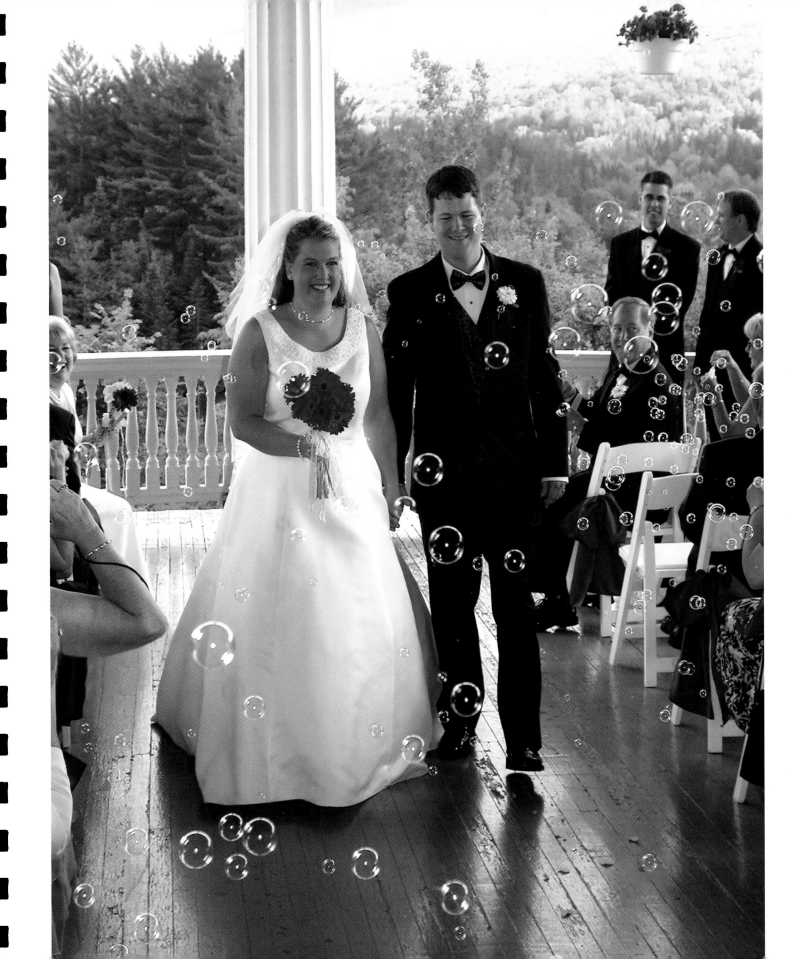

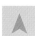 AT THE VERY LEAST, FILL THE FRAME WITH YOUR YOUNG SCHOLAR.

Certain photographs can be broken down into simple elements that work together to tell a story. In this case, the story is short and sweet: A young girl is going to her first day of school.

I know that sounds ridiculously obvious, but let's break this down into its basic elements. The yellow color clearly indicates that she is on a school bus, despite that fact that we don't see a school bus. Everything she is holding and wearing has a spanking clean look—it's probably new. Hence, it's likely the beginning of a school year. She's awfully young, too, so it seems that this is not just a first day of the school year, but her very first day of school. Hence, this is a girl going to her first day of kindergarten. No caption required.

If the bus weren't in the picture, we would still conclude she is going to school but the picture wouldn't be as good. Both the color and framing (we only need to include enough to communicate what it is) ties a ribbon around the idea and makes it visually memorable.

THE FIRST TIME ANYONE DOES ANYTHING IS AN OPPORTUNITY TO TELL A STORY. IF YOU INCORPORATE THE APPROPRIATE VISUAL ELEMENTS, YOU WILL HIT THE BALL OUT OF THE PARK.

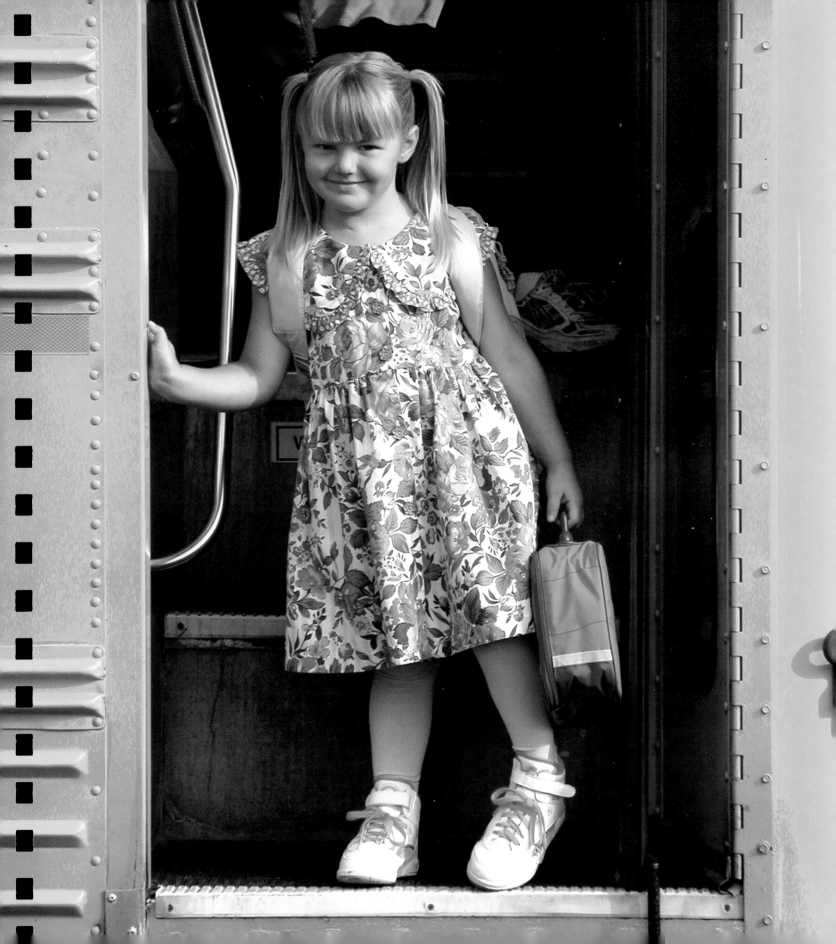

A CHILD'S FIRST BIKE RIDE

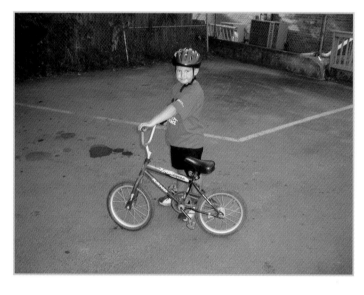

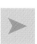 MOST PHOTOGRAPHERS ARE MORE COMFORTABLE WITH SUBJECTS THAT DON'T MOVE. THAT'S WHY PEOPLE OFTEN RESORT TO STIFF, POSED SHOTS.

PREFOCUS TO SEE WHAT YOU CAN DO WITH AN ACTION SHOT. THE MORE CHANCES YOU'RE WILLING TO TAKE, THE LUCKIER YOU'LL GET.

No one ever learns to ride a bike alone, so it only seems fair that a picture of someone learning to ride a bicycle has two people in it.

I was not there when my son rode a bike for the first time. Noreen, who worked in the bike store in Maine, claimed she could teach any five-year-old to ride a bike in thirty minutes. Her only requirement was: "Mom and Dad have to get lost." The moment lives in family history—unphotographed.

I really wish I had a photograph of Chaz and Noreen in the alley behind the bike store, but the main thing we remember about the moment is that Noreen taught him to ride.

Sentiment is fine, but getting it on film can be another matter, especially when the star of the photograph is a young child on a moving bicycle. Focus is the biggest problem. Auto-focus cameras can be less than reliable in action situations. If your camera allows you to manually prefocus, it's well worth the time it takes to learn how to do so. Many cameras will allow you to preset the distance, say 20 feet. Using a telephoto lens, as I did for the photo opposite, will help you to fill the frame. When your young cyclist—or runner or skateboarder—gets to a point 20 feet from you, push the button. If this sounds restrictive, that's because it is, but it is better than a perfectly sharp background and a perfectly out of focus subject. Try it. It works better than you would think.

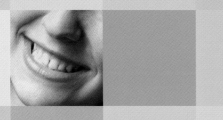

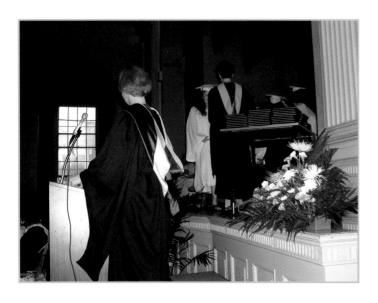

 SOMETIMES YOU HAVE TO WONDER IF PHOTOGRAPHING AN ACTUAL EVENT IS WORTH IT. MAYBE IT'S BETTER TO JUST SIT BACK AND ENJOY, THEN TAKE A MEMORABLE PHOTOGRAPH LATER.

There's no rule that says you need to photographically document the exact moment someone you care about receives a diploma. There are moments we should abandon photography and let the pride swell. But if your child (or boyfriend, or grandmother) has overcome any kind of personal obstacle and risen to the top—or just plain worked hard to get this formal recognition—it's time to get out the camera.

And, I believe, the most important thing to record at that pinnacle is profoundly simple and needs to address one question: What did the person feel like?

We leap from milestone to milestone; our lives are a series of them. There are small milestones: Your child ran through a sprinkler. There are bigger milestones: You ran through a sprinkler. Maybe your mother won an Oscar this year.

Regardless of the accomplishment, in twenty years, the initial reaction to whatever picture is taken today will be, "Oh, my God, look at her." And if you can share that feeling, you will have a photograph that connects people across generations.

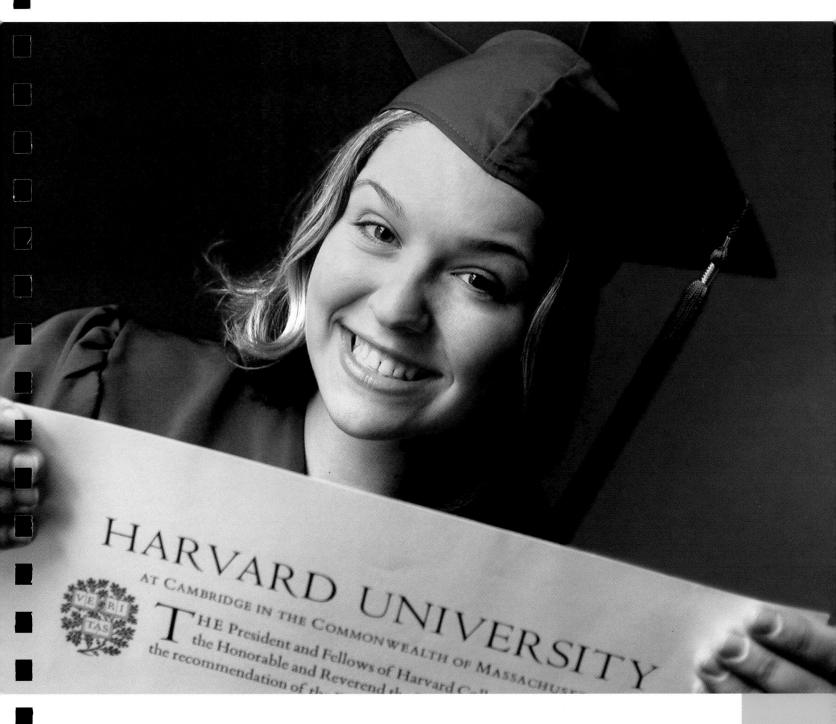

HOW TO PHOTOGRAPH

CHRISTMAS

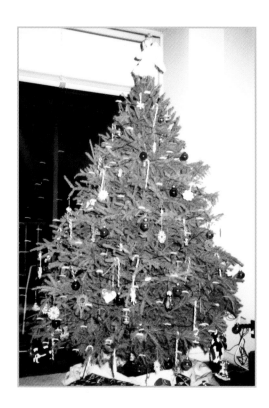

 THE PHOTOGRAPHER
SAW A CHRISTMAS TREE
GLOWING IN THE DARKNESS,
BUT THE CAMERA SAW
CHRISTMAS LIGHTS OVER-
POWERED BY A BUILT-IN
FLASH. UNFORTUNATELY,
THE FLASH WON.

Whenever you are taking a picture near anything that emits light you should be asking yourself, "How can I use this light to my advantage?" The answer will almost assuredly be more aesthetically pleasing than the flash built into your camera. Actually, just about anything is better than the flash on your camera, including an open refrigerator door. I'm serious.

It's true that the lights on a Christmas tree are not very bright, but experimentation with a digital camera, a Christmas tree, and a cute kid can be a major lesson in working with available light. Any photographic subject that emits light deserves first consideration as the main light source.

But there's a problem. Dim light requires long exposures and it's difficult to hold the camera steady for that length of time. The amount of light produced by a Christmas tree is right on the line between requiring a tripod and being able to hand-hold a camera steadily.

Who hasn't been disappointed by the pictures of their Christmas tree? The flash was the problem. Turn it off and experiment with the exposures. Err on the side of too bright and the tree will glow in your pictures just like it did in your memories.

A TRIPOD AND ADVANCED PREPARATION THROUGH EXPOSURE TESTS—BEFORE THE THREE-YEAR-OLD ARRIVED—PRODUCED A SHARP PHOTOGRAPH IN INCREDIBLY LOW LIGHT.

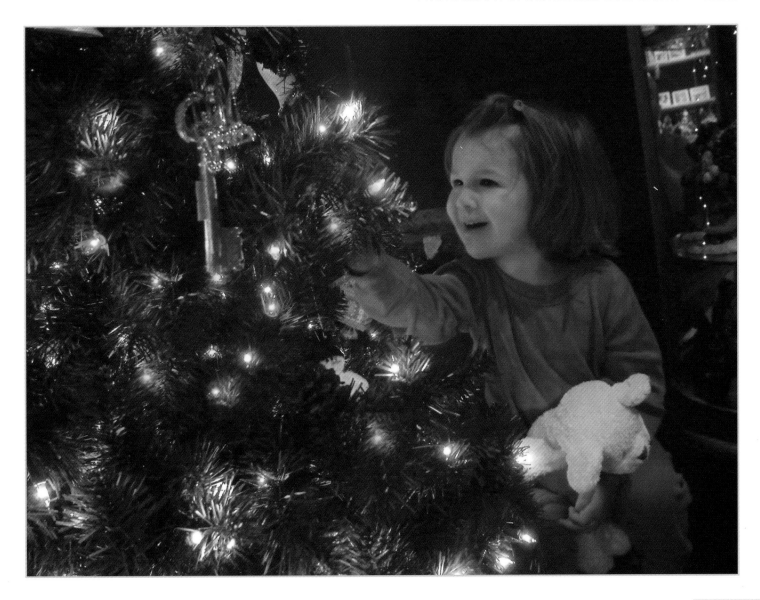

BLACK-AND-WHITE AND COLOR

There are times when the color of a subject is so overwhelming that it practically becomes the subject of the photograph all by itself. A black-and-white picture of a man in a green jacket is a picture of a man, but a color photograph of a man in a green jacket is always going to be a picture of a man in green jacket. If the man just won the Masters, I would say that the picture should be taken in color, but if you want to capture the spirit of a grandfather who just happens to be wearing a green jacket, you might want to consider black and white.

Neither one of these pictures is better than the other, but you to need make a decision. Color is not always better; sometimes it makes a statement that you don't want to make.

I COULD SAY GOOD THINGS ABOUT BOTH OF THESE PICTURES. ONLY YOU CAN DECIDE IF BLACK-AND-WHITE OR COLOR MAKES THE STATEMENT YOU WANT TO MAKE. BUT IT'S A DECISION WELL WORTH MAKING. DIGITAL CAMERAS MAKE IT EASY TO SWITCH BACK AND FORTH.

THE BIRTH
OF A BABY

I went to the birth of my new friend Matthew knowing exactly what picture I wanted—a close-up of the moment his mother first laid eye on him. I was going to tell you everything else in a delivery room is extraneous—it's all about a mother and a baby. So I shot twenty-nine close-ups and the picture on the opposite page.

Despite all of your preconceived notions and planning, you have to be ready for the unexpected and push the button without thinking.

It was a delivery by C-section. I was told to stand behind a blind, next to the mother's head and the baby's father. I would get my picture when they brought the baby to them. I was in total control.

We heard the infant cry and the doctor said to the parents, "You have two boys at home, right?"

"That's right," they said.

"And you're hoping for a girl?"

"Yes, we are," they responded.

"Then maybe we should put this one back," he said as he held Matthew up to meet his mother. I barely got the camera to my eye before I pushed the button and it was all over. He did not put Matthew back.

I've photographed six births in my life, including Matthew's, and I still can't get a handle on whether the nurses get choked up because I do or if it's just part of their standard miraculous procedure.

YOU WILL HAVE PLENTY OF TIME TO PHOTOGRAPH
THE NEWBORN BABY LATER, BUT A MOTHER
MEETS HER BABY ONLY ONCE.

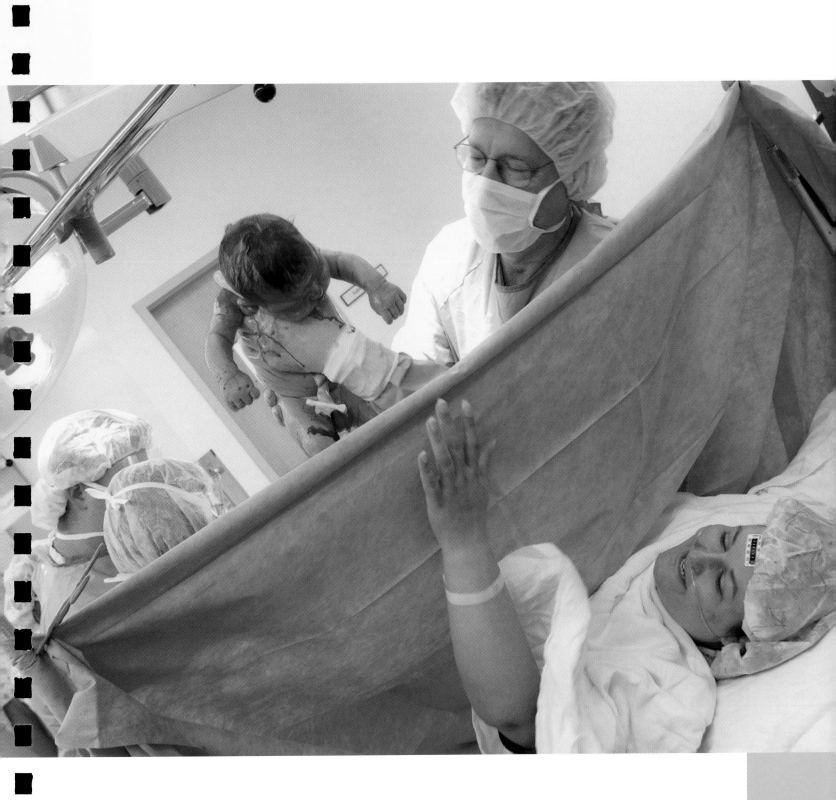

A BABY IN A BATHTUB

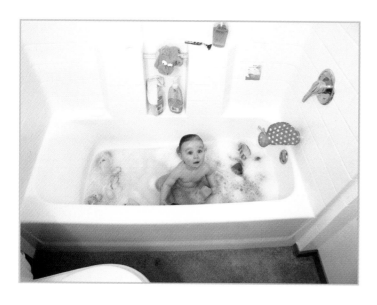

THIS IS THE CLASSIC: A 5½-FOOT TALL ADULT SHOOTS STRAIGHT DOWN ON A BABY IN A BATHTUB. WE CAN DO BETTER.

My brother Eric begged me to let him photograph his daughter, Madison for this book. I told him if he took a picture of her in a bathtub that I liked I would use it.

The first picture he sent me is on the left. It's the one that has been taken since babies and bathtubs were invented. "Not good enough," I said. "Try another angle. Do something different." I was not hopeful. My brother is a salesman.

Then he sent me one hundred pictures of his daughter with this apology: "I couldn't get her to look in the camera." It had never occurred to me to tell him what I consider to be obvious: She does not have to look in the camera.

The happy ending is this: I am proud to present Eric Kelsh's first published photograph. He held the camera 6 inches above the water using the digital screen on the camera to compose. He shot lots of pictures. Most of them were out of focus; some were not. He turned off the flash. He experimented. He played. He bathed his baby three times in one day. He did a lot of things right.

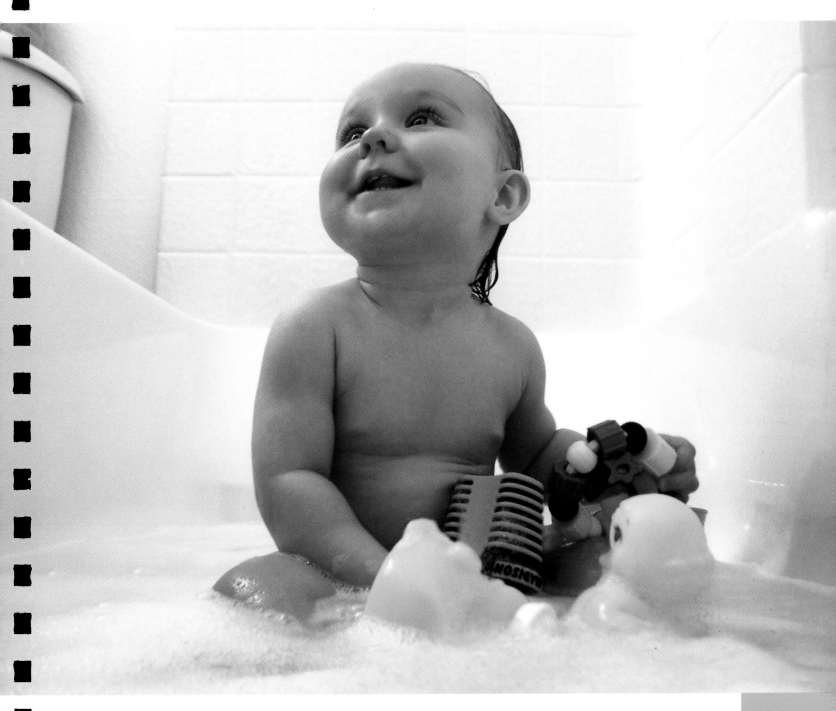

A FAMILY MEETING A NEW BABY

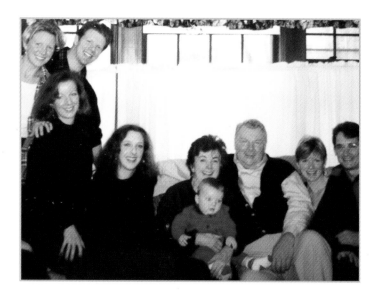

THERE'S CERTAINLY NOTHING WRONG WITH THIS APPROACH: EVERYONE GATHERS AROUND THE BABY AND LOOKS INTO THE CAMERA...

The logical centerpiece of any photograph of a family meeting a new baby is the baby. It's difficult to point your camera anywhere else. But at times like this you need to prioritize what you photograph. You can photograph the baby later, but the reaction of the family will only happen once—and that's right now.

Sometimes the very best angle for the photographer is looking over the shoulder of the most important person in the room. I'd like to believe that Norman Rockwell would enjoy this picture. He certainly understood the visual power of human reaction. His illustration "Homecoming," in which a neighborhood welcomes a World War II soldier returning home, probably had something to do with me taking this picture.

The scene you see here happens every time a new baby is carried into a room, but this is not a photograph that amateurs shoot. Photographing reaction is something that is learned and it will make you appreciate what is happening in a room even when you're not taking pictures.

. . .BUT WHEN A NEW BABY ENTERS THE ROOM THERE ARE NUMEROUS SPONTANEOUS MOMENTS TO BE DOCUMENTED.

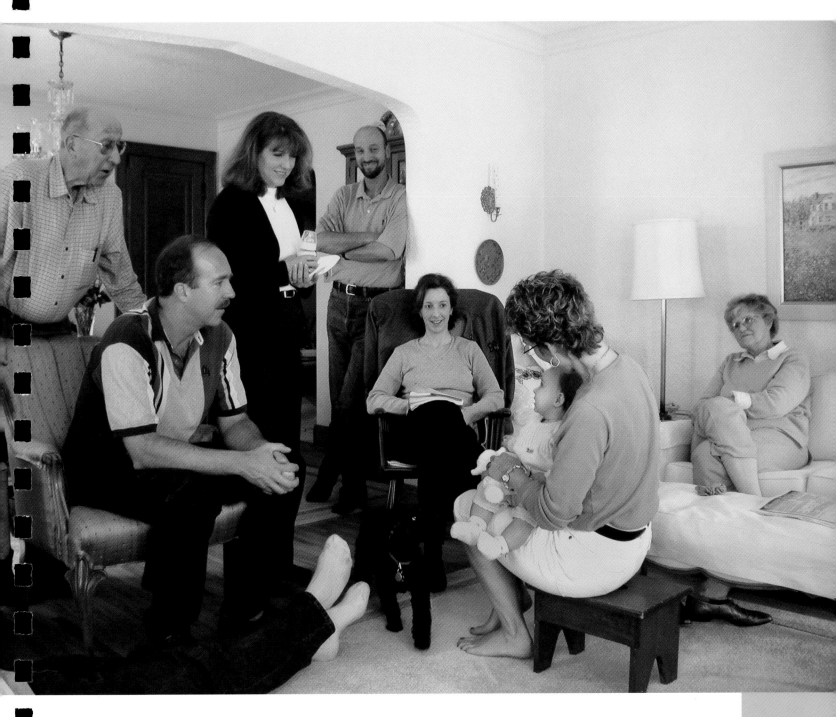

HOW TO PHOTOGRAPH

A HIKE IN THE WOODS

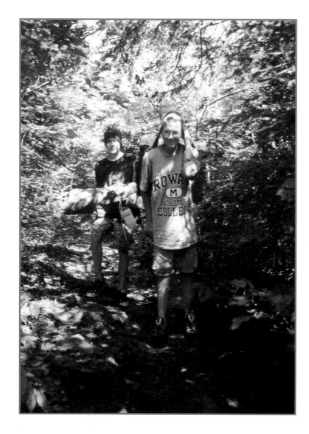

A SUNNY DAY IN THE WOODS
IS DIFFICULT FOR EVEN THE
FINEST PHOTOGRAPHERS.
I SIMPLY AVOID IT.

This is an exercise in understanding light and it's a very important one.

On first glance it sounds great: beautiful trees, sun, nice color. But if a professional is going to shoot a portrait in the woods, he or she is hoping for a cloudy day.

A forest on a sunny day, despite what most amateurs think, is a difficult locale to shoot a portrait. The light is splotchy, and uneven splotchy light is just about always bad. If one person is standing in a spot of shade, the other is bound to be hit by a direct ray of overhead sun, casting an unattractive shadow across the face. Someone's in the shade, someone's in the sun—it's a tough situation even for the best photographers (who would try to avoid it).

I had been taking pictures for years before I realized that cloudy days are often better for photography than sunny days. It sounds so simple and so obvious to me now, decades later. But it's a barrier in thinking that amateurs need to break through.

A CLOUDY DAY CAN BE A GODSEND, DESPITE WHAT MOST AMATEURS BELIEVE.

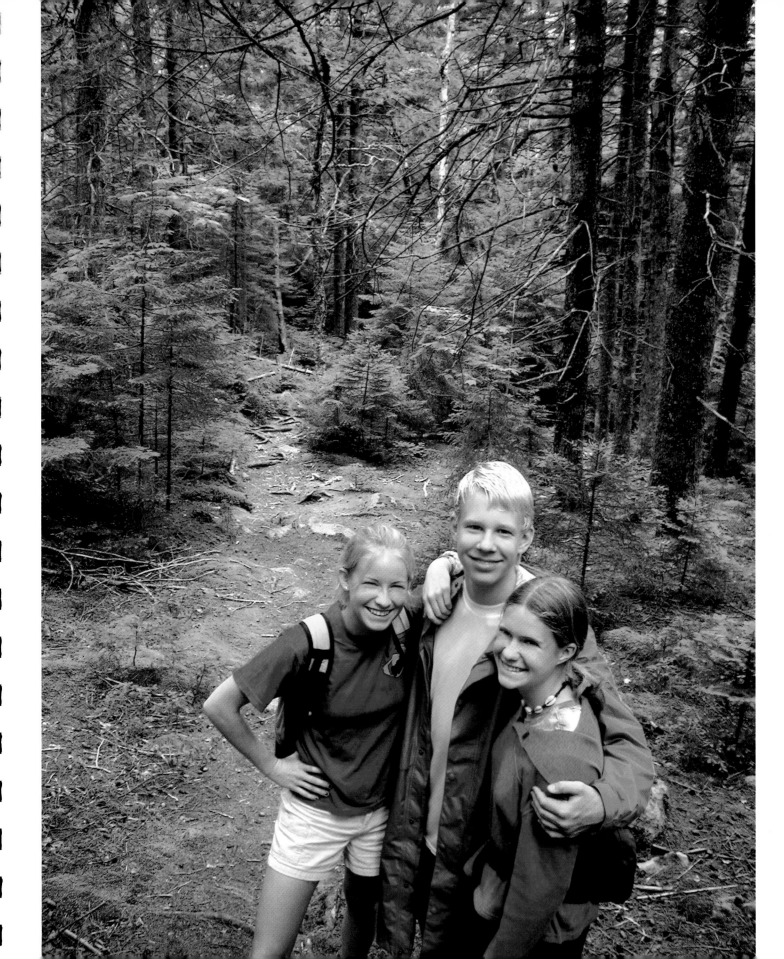

A
LANDSCAPE I

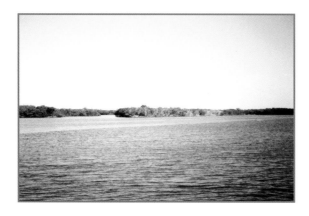

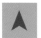 IT'S VERY SIMPLE: HORIZONS
DO NOT BELONG IN THE MIDDLE
OF A PICTURE.

Our physical concept of the world goes something like this: The sky is above and the earth is below so the horizon must belong right in the middle.

The most common mistake an amateur photographer will make when taking a landscape picture is to run the horizon straight through the middle of the frame. Resulting picture: half earth, half sky.

Regardless of where the horizon is in reality, visually speaking it does not belong in the middle. Ask yourself what's more important in the photograph: the sky or the ground? There is no one correct answer, of course. Every situation is different. But do your very best to make a decision and adjust the frame accordingly. Your pictures will be better for it.

To the professional eye, a picture with the horizon line placed dead center is a picture taken by someone who couldn't make a decision.

MOVE THE HORIZON TO THE TOP THIRD OF THE PICTURE,
PUT SOMETHING IN THE FOREGROUND—IN THIS CASE, ROCKS
AND REEDS—AND SOMETHING SIGNIFICANT HAPPENS.

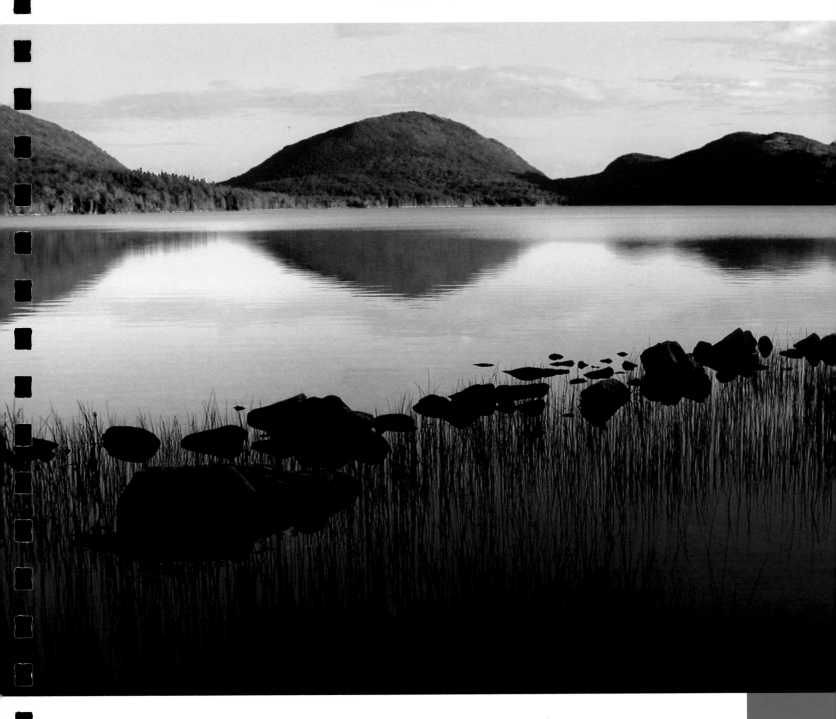

When I was in college, the great *Life* magazine photographer Alfred Eisenstadt came to speak. "Do you have any advice for young photographers?" one of my fellow students asked. "Yes," he said. "Get out of the car." That advice works on so many levels.

To the right is a picture I don't think many amateurs would get out of the car to shoot. At high noon, to the jaded eye, this would be just a just a swamp. In early evening, it's heavenly—and it was all just a matter of lighting. That, and thinking enough to turn the camera on its side for a vertical view. It's amazing how this one thing can dramatically improve an image.

AMATEURS ARE DOOMED TO SHOOT HORIZONTALS. TRUST ME, THE CAMERA WILL WORK WHEN YOU TURN IT ON ITS SIDE, TOO.

TAKE A DIFFERENT APPROACH— SHOOT A LANDSCAPE AS A VERTICAL; CROP IN TIGHT; TAKE A TELEPHOTO VIEW—AND GET OUT OF THE CAR.

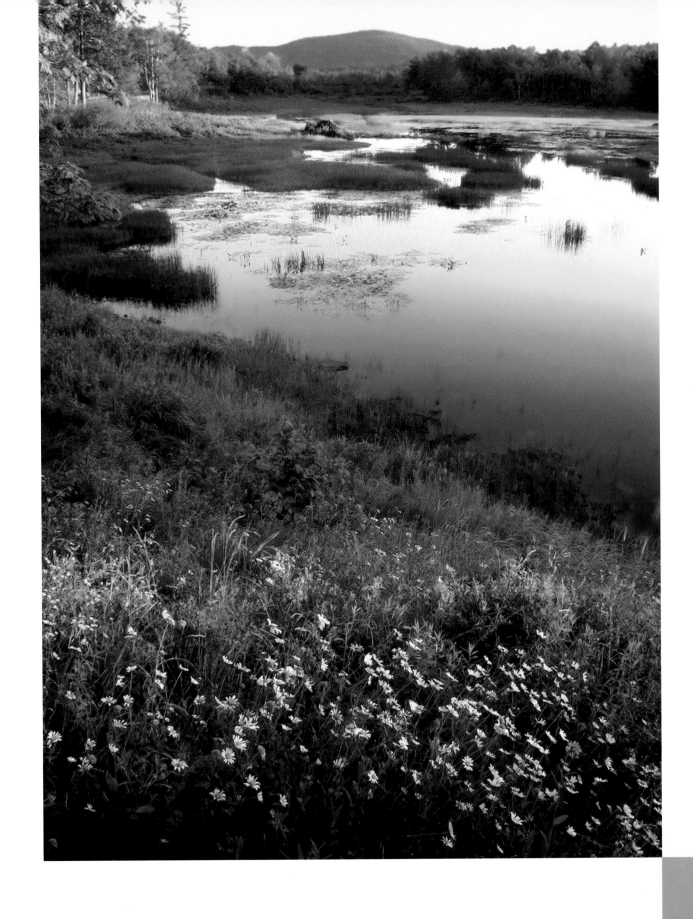

HOW TO PHOTOGRAPH
AN ANIMAL
AT THE ZOO

You can take wonderful photographs of animals in zoos that look like they were taken in the wild, but you must spend most of your time thinking about one thing: backgrounds.

Good photographers are always dealing with what's behind their subjects and I can't think of a situation in which that's more obvious than the zoo. Telephone wires and cinderblock walls do not belong in pictures with zebras and kangaroos. Professionals are constantly changing angles or lenses or locations or simply giving up because they don't like the foreground or background.

 FOREGROUNDS CAN BE A PROBLEM TOO. CERTAIN CAGES OR FENCES WILL SIMPLY NOT ALLOW A NATURAL LOOKING SHOT.

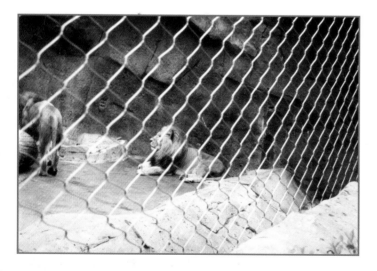

At the zoo, the most obvious solution is to keep your lens zoomed all the way out, then reposition yourself to accommodate what you want to see in the viewfinder. That is, you get closer or move farther away but leave the lens at its maximum telephoto setting.

It's so easy to ignore—or just not notice—distracting elements that are sharing your viewfinder with the good stuff. After all, the good stuff looks so good, how bad could the bad stuff be? The answer is, pretty bad. You have to consider everything you see when you look through your camera. Distracting elements that appeared insignificant in the viewfinder have a way of jumping out of your prints to bite you later.

The other problem you will have at zoos is shooting through glass that is often scratched or dirty. It's a difficult situation and usually all you can do is turn the flash off to avoid ugly reflections and hope for the best.

IT TOOK SEVERAL MINUTES OF WAITING ON MY PART, BUT THE GIRAFFE FINALLY POSITIONED ITSELF IN FRONT OF A COMPLETELY NATURAL BACK-GROUND. THEN I SHOT TWENTY-FIVE PICTURES IN THREE MINUTES.

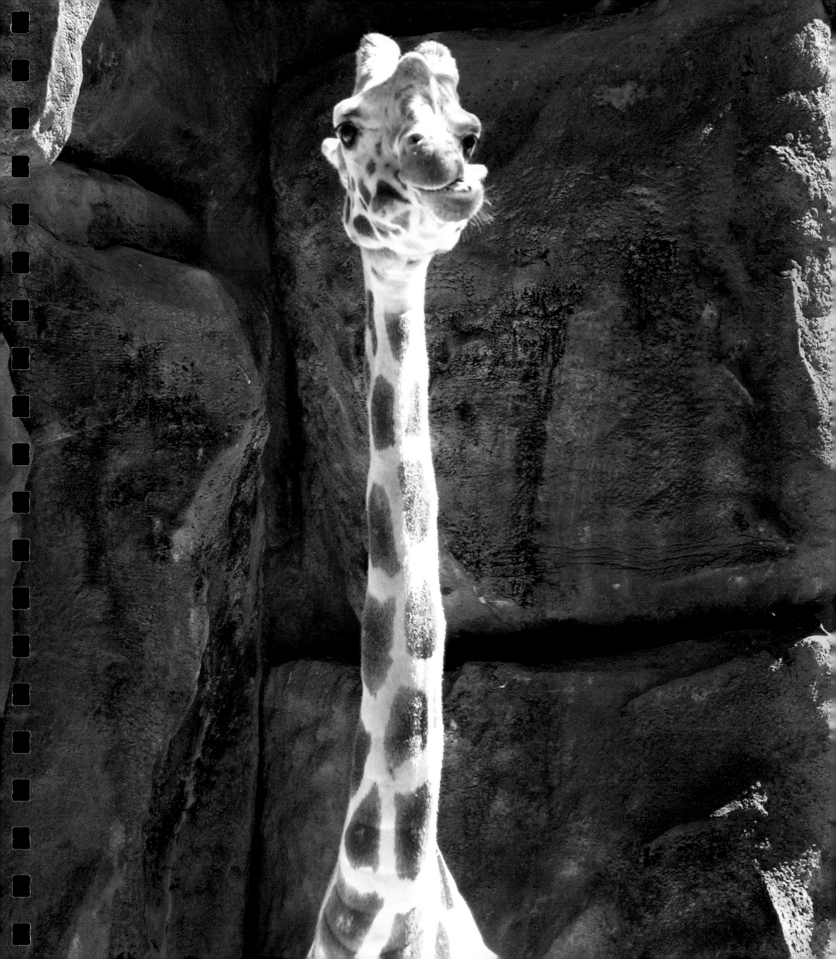

HOW TO PHOTOGRAPH

IN THE RAIN

Too many photographers hang their cameras up when the rain starts. Can't you just hear them? "What a bad day for taking pictures," they'll say.

The picture on the opposite page flies in the face of such amateur thinking: You can take pictures on a rainy day and this picture proves it. You just have to want to. In this case, I wanted to so much I let my wife get soaking wet as she held an

▼ AMATEURS LOVE SUNSHINE BECAUSE IT MAKES PICTURE-TAKING EASY. YOU JUST GRAB A CAMERA AND SHOOT.

umbrella over me. As long as you can keep actual raindrops off the lens itself, you have a good chance of shooting clear sharp pictures.

There are situations that amateurs believe are not photo opportunities: night, fog, blizzards, car interiors, basements. But while other people are overwhelmed by the weather or their surroundings and forget about their cameras, you can capture some wonderful spontaneous moments.

This picture was taken during a torrential downpour and yet you can't see the actual raindrops. The rain was coming down so fast that the drops are blurred to the point of invisibility, making the rushing water in the gutter all the more important as a story-telling element.

Even a snowfall will vanish if your shutter speed is not fast enough. The very best falling snow photographs are taken when the individual flakes are huge and the wind is not blowing them around. You still need to use the fastest shutter speed you can to freeze them (no pun intended) in midair.

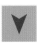

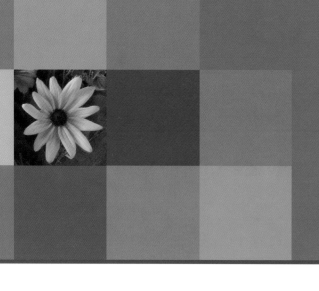

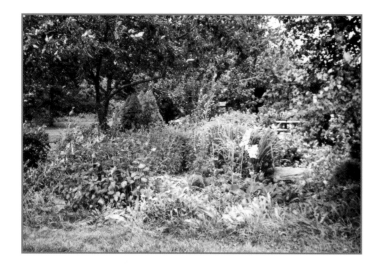

 SOME GARDENS LEND THEMSELVES TO PHOTOGRAPHY, BUT MOST DON'T. THIS PORTRAIT OF A GARDEN IS ABOUT 95 PERCENT GREEN.

A garden can be an island of beauty in an otherwise visually bleak world and yet, despite the best efforts of good photographers, they often don't photograph very well.

When you shoot an overall view of a garden, you are spreading the beauty thinly across the image—lots of little points of color against a background of pretty, but monotonous, green. The best things in gardens are almost always viewed close up, so if you're standing 20 feet from your plants when you're pushing the button, the good stuff just got real small. In the garden you need to get closer—and somehow manage to put as many good elements as possible in the frame.

But if you love your flowers, and you want to photograph lots of them in one picture, I think a good solution is to get the best of your garden and put it into a small space. Hey! I just invented the bouquet. It's the botanical equivalent of asking people to put their heads close together when they're having their picture taken (see How to Photograph a Group, page 88).

IF FLOWERS ARE WHAT YOU LOVE, THEN PHOTOGRAPH THE FLOWERS AND DO YOUR BEST TO ELIMINATE EVERYTHING ELSE. APPLY THAT KIND OF THINKING TO EVERYTHING YOU PHOTOGRAPH.

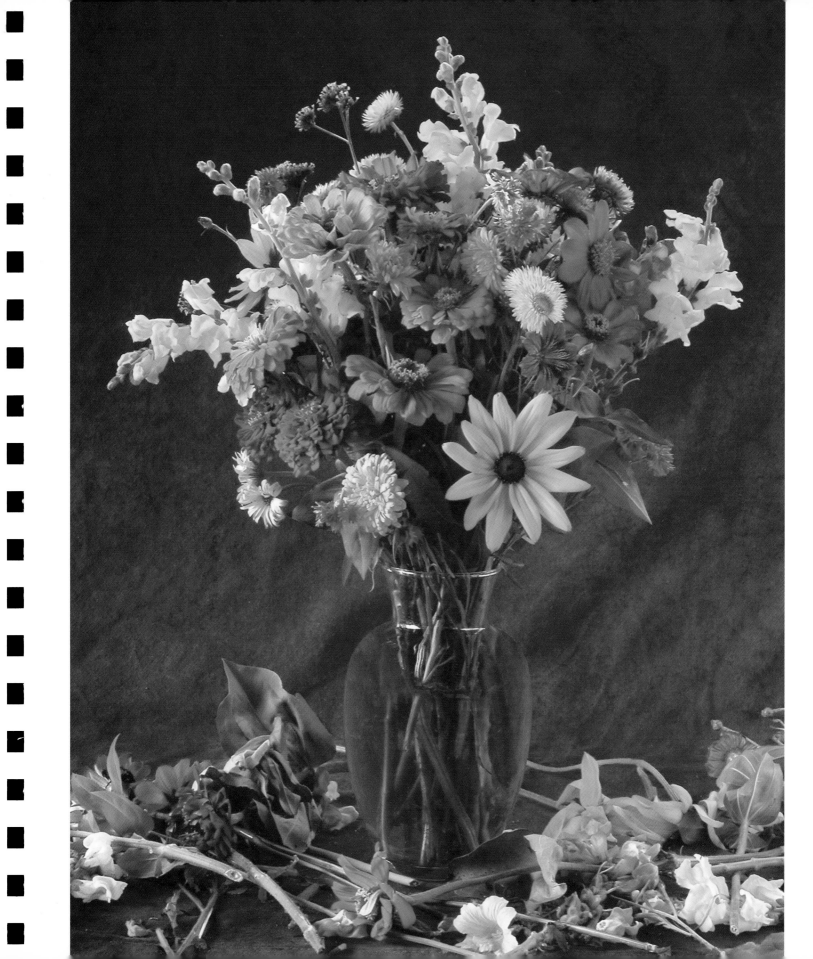

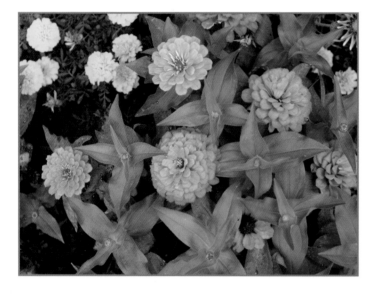

▲ GETTING CLOSER IS OFTEN STILL
NOT CLOSE ENOUGH.

An afternoon spent shooting close-ups of beautiful flowers can be downright inspiring.

Many of the new amateur cameras will let you focus incredibly close, and you should take advantage of this, although it is not quite as simple as it may sound. This is another situation when a tripod is, if not mandatory, then very useful.

The technical term for the problem is depth of field. The closer you get to an object the more things go out of focus. If you use a small *f*-stop, things will start to get sharper— it's like squinting.

Crop in to the flower as close as your camera will allow, even if it means cropping off the edges of some of the petals. Do your very best to fill the frame with color. Even if you can't rhyme, be a poet. Use a tripod and learn how the macro focus works on your camera (there is wonderful stuff in your instruction manual).

PHOTOGRAPHING AN EXTREME CLOSE-UP
OF A FLOWER REQUIRES MASTERY
OF YOUR CAMERA. HOW CLOSE WILL IT
FOCUS? DO YOU NEED A TRIPOD? ONLY
EXPERIMENTATION WILL TELL YOU.

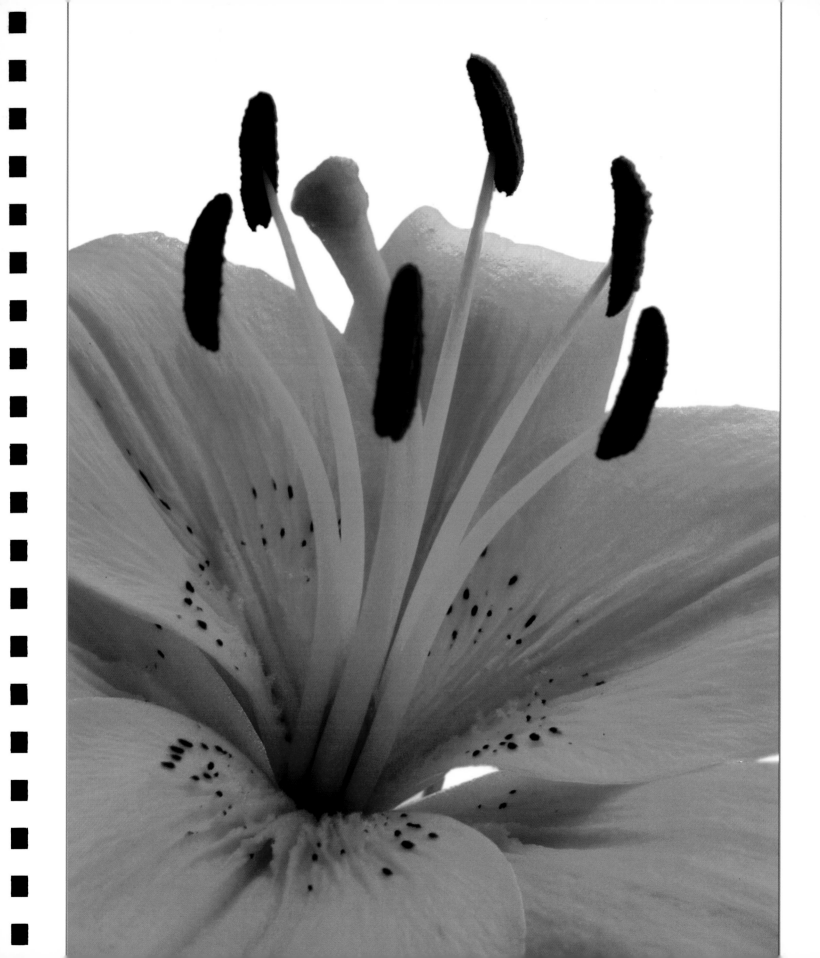

FIND THE PICTURE WITHIN THE PICTURE

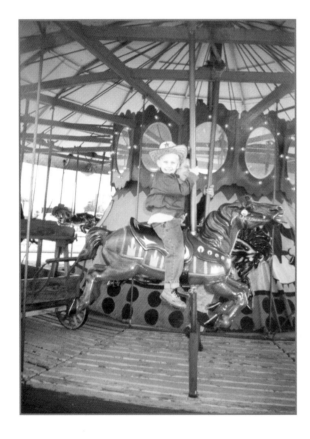

BY ALL MEANS PHOTOGRAPH YOUR CHILD RIDING A CAROUSEL, BUT WOULDN'T CLOSE-UPS OF THE HORSES ALSO LOOK GOOD HANGING HIS ROOM?

People don't have to be in all of your photographs. Tightly cropped close-ups of things you love can turn you into an artist.

I spent about fifteen minutes shooting the pictures you see here. The carousel horses were so colorfully diverse that I couldn't resist. I was just playing with composition and design, trying to please no one but myself. I had no idea what I would do these pictures, if anything, but I just kept pushing the button.

I've had the same reaction to rocks on a beach and piles of leaves under trees. There is beauty in the details if you only look for them. Honing in on details solves any background problems—there is no background—and removes extraneous eye-catching distractions in one giant step. You will surprise yourself with what you can find in the most unlikely of locations. One of the most beautiful nature shots I've ever taken was a close-up of weeds growing in a ditch next to a junkyard.

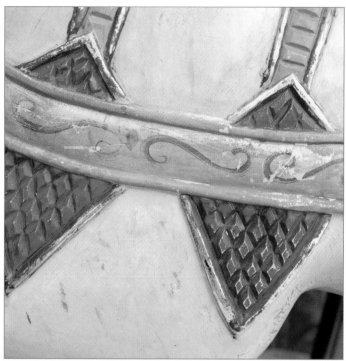

HOW TO PHOTOGRAPH
A SUNSET

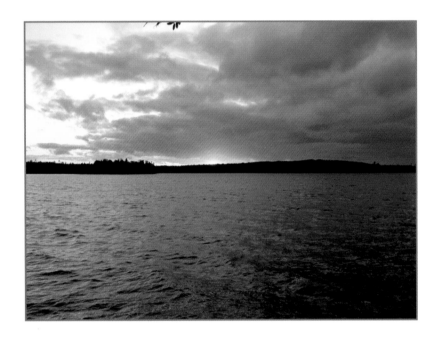

Sunset occurs when the sun disappears below the horizon line of the earth. Astronomers can actually pinpoint the moment in fractions of seconds. It's that moment so wonderful to witness, that last little slice of the glorious sphere. It's a marvelous experience, but it's not always the best moment to photograph.

Photographic sunset is a much cloudier entity. The best photographs of "sunset" often happen several minutes before or after the official disappearance. It's the light bouncing off the atmosphere that really makes incredible color, enhancing the mood and therefore the photographs. It's the atmosphere itself that is often the star of the show.

It's entirely possible that when the ball of the sun has disappeared, the best photograph happened ten minutes ago—or is yet to come.

THESE PICTURES WERE TAKEN TEN MINUTES APART. THE DIFFERENCE IS, WELL, ALMOST NIGHT AND DAY. PEAK OPPORTUNITIES CAN HAPPEN BEFORE OR AFTER THE SUN ACTUALLY DROPS BELOW THE HORIZON.

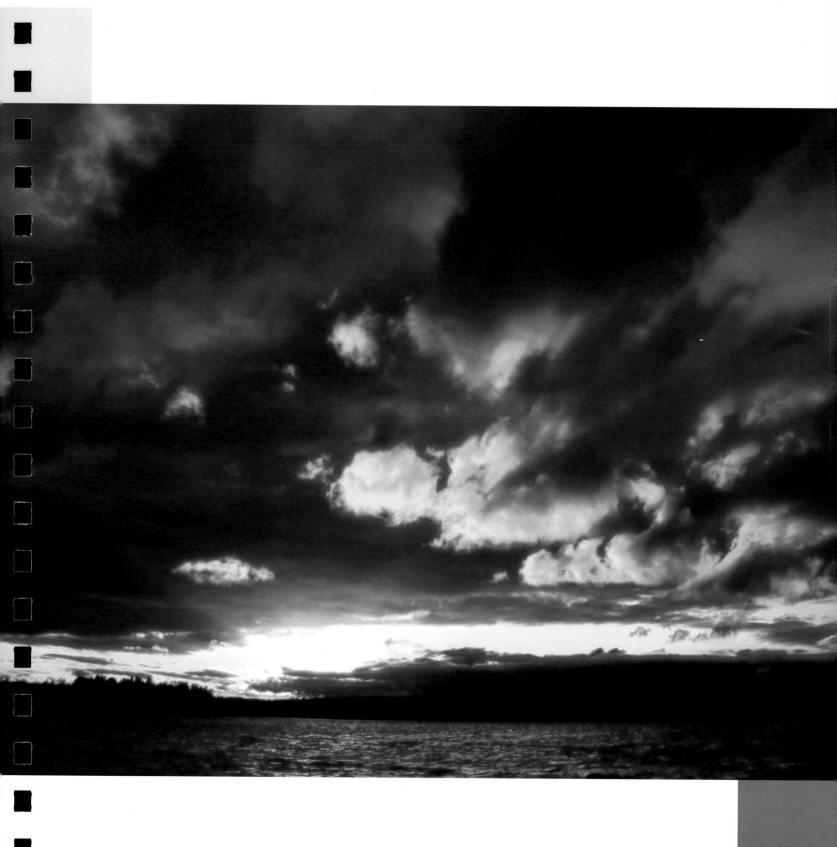

HOW TO PHOTOGRAPH
CLOUDS

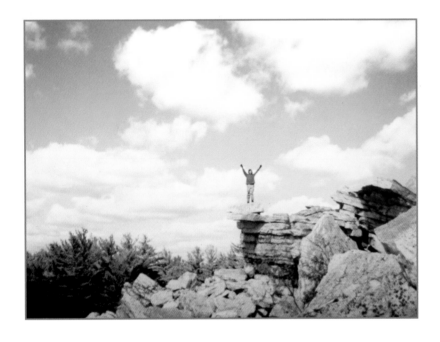

ALL PHOTOGRAPHERS ARE ATTRACTED TO CLOUDS, BUT VERY FEW OF THEM ARE WILLING TO ELIMINATE PEOPLE AND LANDSCAPES FROM WHAT CAN BE A SIMPLE ELEGANT COMPOSITION.

Aside from the pencil, I can't think of a more accessible tool for self-expression than the camera. It is sold in convenience stores. Ballet slippers are not sold in convenience stores.

Maybe if cameras were only sold in art supply stores, more people would think of using them as tools for creating beauty. However, in the world at large the camera is simply used as a tool to record what things look like. Period.

In its most pure form, the camera is a tool for showing other people what you see. It's that simple. There is really no other way. You can tell them you saw beautiful clouds on the way home last night or you can show them a picture. A picture is worth, well, a lot.

Photographing things other people don't photograph is perhaps the quickest way to break away from the pack.

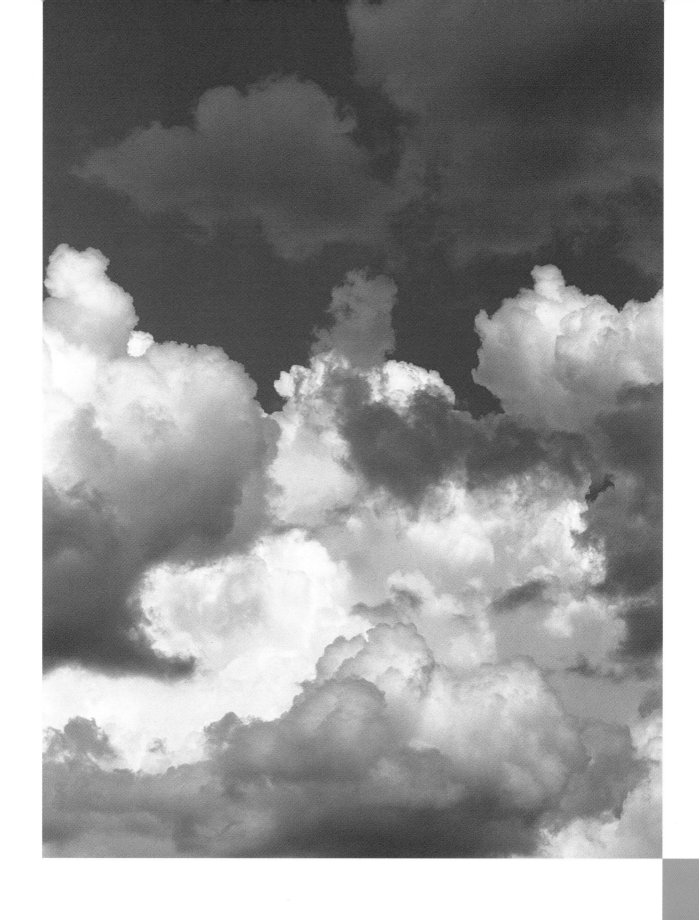

▲ THIS IS WHAT TO WATCH OUT FOR:
BRIGHT COLOR AND DARK SHADOWS.
IT JUST NEVER LOOKS AS GOOD
WHEN YOU SEE YOUR PICTURES
AT HOME.

Surprisingly, fall foliage often looks better when photographed on a cloudy day. "What about a series of Vermont hills against a blue sky?" you might say. "Does it get much prettier than that?"

Well, yes and no. Here's what happens: The direct sunlight increases the overall contrast, often losing significant color in the shadow. The downside is that on cloudy days the sky often appears dull white. But if you are careful about your backgrounds, which is to say thinking like a professional, you can work around it and capture the saturated color you see with your eyes. If the sky doesn't add anything—leave it out.

Shooting on a cloudy day is a lesson in understanding your medium, dealing with what you've got, and letting your camera sing.

ONCE AGAIN, SOFT LIGHT
IS THE ANSWER—IN THIS CASE,
AN OVERCAST DAY. ▶

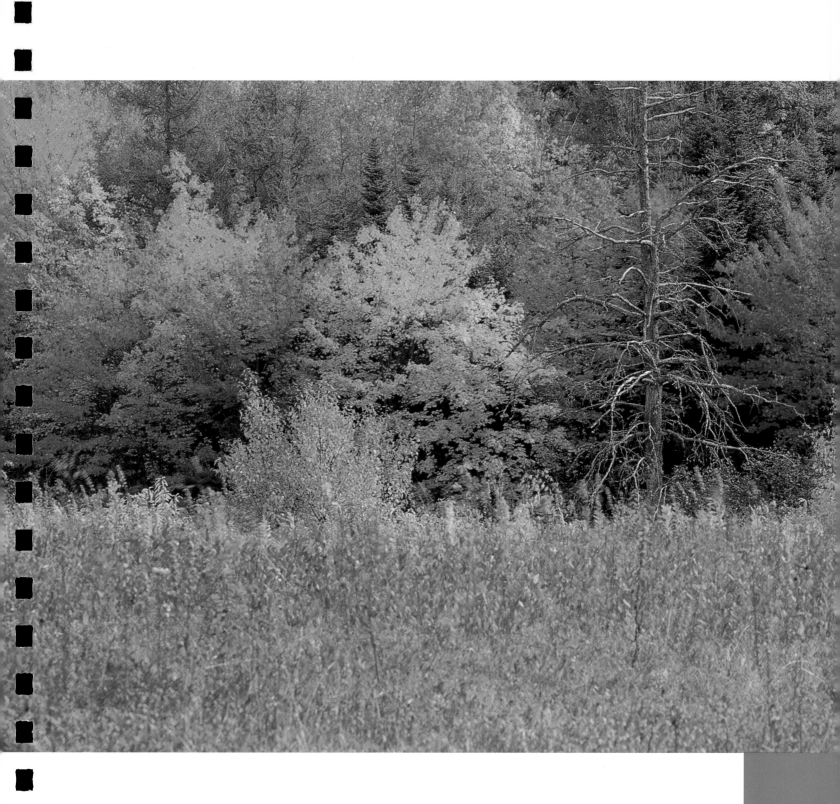

HOW TO PHOTOGRAPH
A MONUMENT

There is certainly nothing wrong with photographing the views you see on postcards of well-known sites. In fact, the postcard rack is a good place to establish in your mind what already has been done a million times.

This also makes a famous monument a great place to exercise your visual muscles. There it sits, just as it has for every other photographer who has stood on that ground. The only flexible component in the equation is your brain. Unusual angles or unusual cropping will often produce compelling photographs that will nicely complement the standard, predictable views.

In the end, the front of the Statue of Liberty is probably a better photograph than the back. But the fact we have seen thousands of pictures from the same angle, by default, makes her back worth a second look.

THESE IMAGES ILLUSTRATE NOT ONLY THAT YOU WERE THERE, BUT WHAT MADE AN IMPRESSION ON YOU.

EVERYONE WANTS A VISUAL RECORD OF A VISIT TO A FAMOUS MONUMENT, BUT YOU DON'T ALWAYS HAVE TO BE IN THE PICTURE.

HOW TO PHOTOGRAPH

YOUR VACATION

GOOD VACATION PHOTOGRAPHY is just someone playing with a camera, loving what he or she is doing, and trying to record memories.

I have a friend who visited Mexico for two weeks. He then invited his friends over for chips, salsa, and a look at his vacation slides. The entire show consisted of everything he and his wife had eaten on their trip—including airplane peanuts. Twenty-five years later, it still ranks as one of the funniest things I've ever seen.

You don't have to take funny pictures on your vacation, but if you just play, if you just photograph things you've never photographed before, you are going to surprise yourself and everyone who sees your pictures.

It will require an eye for detail and a willingness to shoot in a variety of styles. Your pictures do not have to be perfect. In fact, if they are a little rough around the edges it will just add an air of spontaneity. If your goal is to produce a pile of snapshots that you can put in a photo album, then breaking it up with different shooting styles will go a long way toward giving it the kind of impact that will not only impress people, but also strike many an emotional chord. You can have fun pictures, dark and moody pictures, pictures of your shoes, close-ups, overall shots, the guy behind the grill at the diner.

When you vacation you are continually experiencing things you will appreciate a picture of later, even though you may not realize it at the time. Never is it more important to shoot now, as you most surely will not pass this way again.

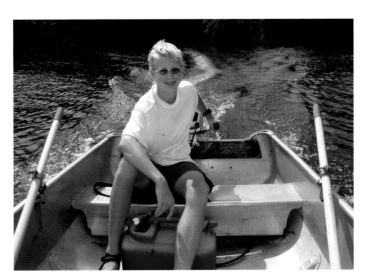

HOW *NOT* TO PHOTOGRAPH

YOUR
VACATION

BAD VACATION PHOTOGRAPHY is concentrated bad photography. In the hands of a compulsive, bad photographer, the camera becomes if not a weapon or a shackle, then at least an anchor hanging about the neck.

For many people, a vacation represents one year's photographic efforts. So if we were to observe one vacation's worth of pictures we would probably find ourselves staring a bad habit in the face. Scientifically speaking, our data would show the following:

- Repetition of approach

- Disregard for aesthetics in general:
 That is, light, color, and composition.

- Disregard for human emotion in general.
 Emotion lacking in all images.

- A chronic feeling of obligatory photography.

- A decided lack of fun.

And I really think that's all it is. It's nothing but a bad habit. People take bad pictures because that's what they've always done. Stand here. Look here. They are restrained by the way their parents took pictures. "And they've seen it done in countless other people's unendurable vacation slides. It's the standard approach for vacationing families, and if you're just two people traveling together it's even worse; you think your only options are to hand the camera to each other or a stranger and just capture yourselves in front of every attraction you visit. We are feeding a habit here.

The photos opposite do prove that my wife and her former boyfriend saw all of Japan's temples and shrines, but their actual "vacation" remains a mystery to me. I'm giving her this book (with this section bookmarked) for her next birthday."

THESE PAGES DEPRESS ME.
PLEASE OPEN THE GATEFOLD.

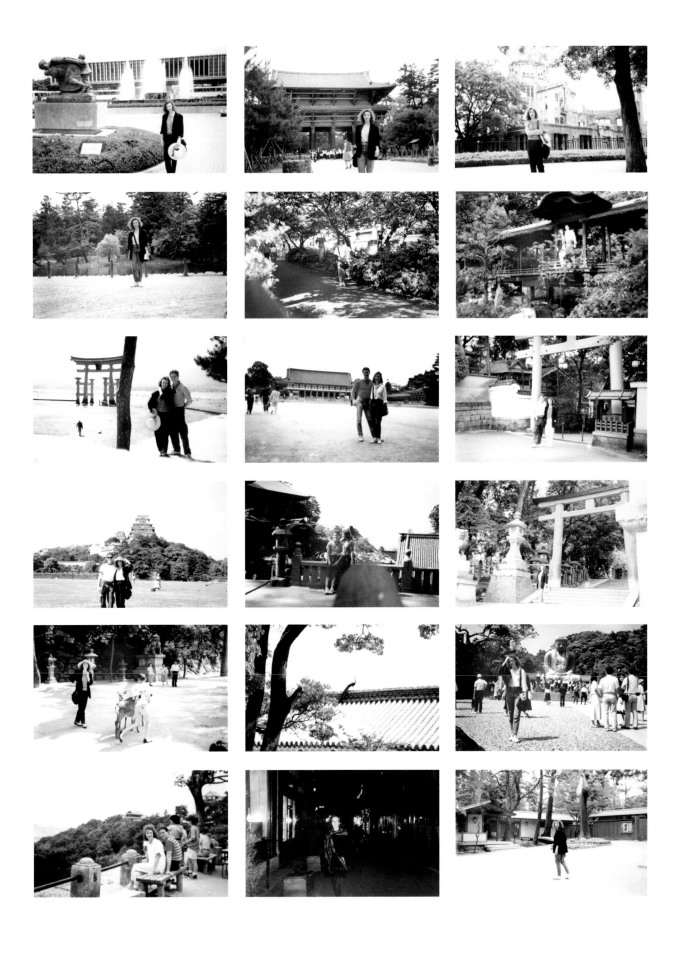

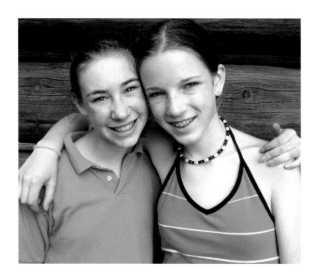

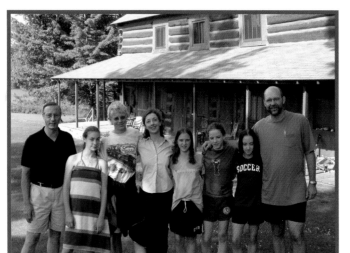
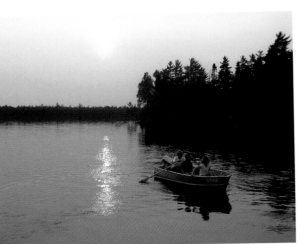

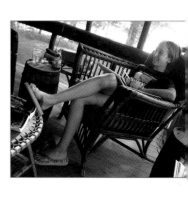
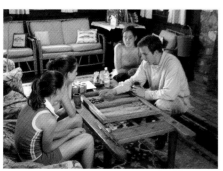

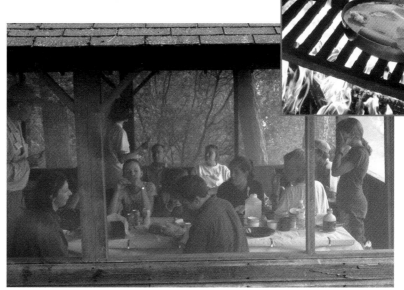

HOW TO PHOTOGRAPH

A CITY SKYLINE

There are few examples in this book that will give you more enjoyment and edification than the following and I hope it will leave you saying, "Wow."

It will change the way you view light at dusk and you will be shocked by the capabilities of a digital camera. The effects are dramatic with a film camera, too, but it's instant viewing that really drives this lesson home.

On a clear day, spend one hour photographing a city skyline. Start about fifteen minutes before sunset. Use a tripod. Shoot a picture every few minutes regardless of whether you think that the picture you are now taking looks just like the one you shot three minutes ago. Shoot through sunset and into late twilight. Shoot until the brightest thing in the scene is the light in the windows of the buildings. Then review all of the pictures in the order you shot them.

The digital camera was seeing things that you were not. Notice as the color in the sky subtly changes from picture to picture and yet is dramatically altered in just twenty minutes. Watch as the lights in windows go from being imperceptible to the dominant thing in the picture.

But most importantly, notice that in one of the photographs the window lights in the buildings are balanced with the light of the sky. It's a magic moment and does not last long. If you shoot a picture every three minutes, in the end, you will have one frame that stands out as the best—or at least, your favorite.

A PERFECTLY CLEAR MIDDAY VIEW OF A CITY SKYLINE IS A RARITY. A TWILIGHT VIEW WITH THE CITY LIGHTS CUTTING THROUGH THE HAZE IS ALMOST ALWAYS BETTER.

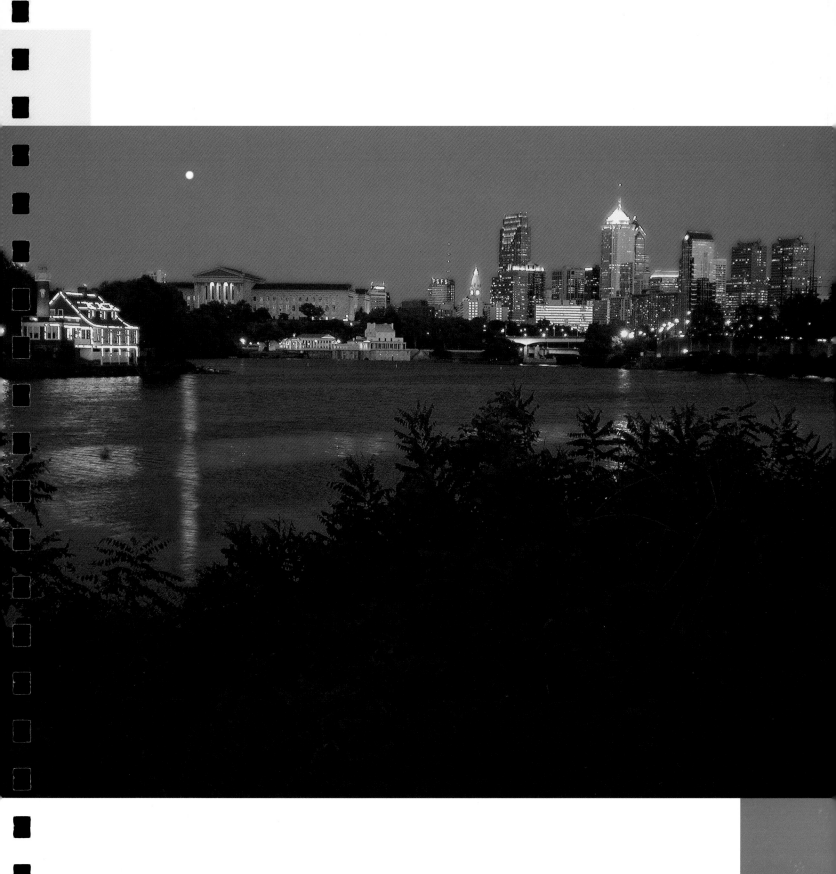

HOW TO PHOTOGRAPH

YOUR HOUSE

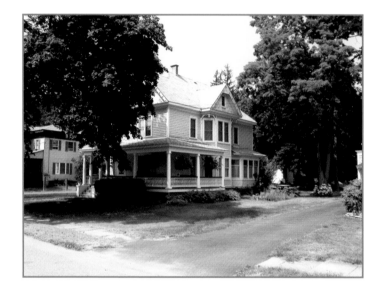

As you study which picture of a city skyline simply looks better to you, note the different moods of the individual photographs. None is really superior to another; they are just different. Same buildings, same angle of view, only a shift in lighting.

Appreciate the effect light is having on your feelings now and how it will affect what—and when—you photograph in the future. Now apply a similar experiment to photographing a house. Take one picture at noon and another at that moment in the evening when the interior lights of the house and the background sky are balanced.

It's the difference between a real estate ad and a photograph of a warm, inviting home.

SENSITIVITY TO THOSE MAGIC
MOMENTS WHEN INTERIOR
LIGHT MATCHES EXTERIOR LIGHT
WILL TRANSFORM A HOUSE
INTO A HOME.

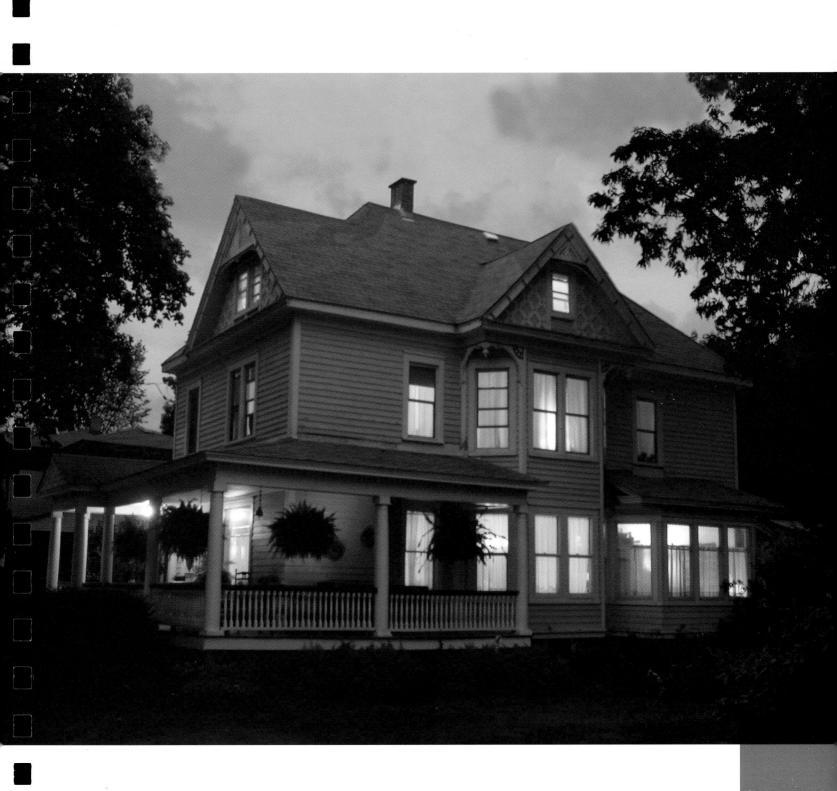

BRIGHT LIGHTS

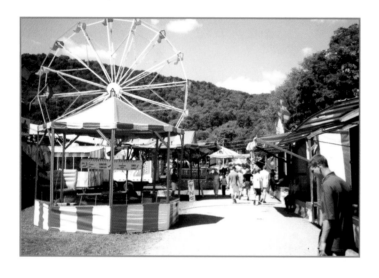

 THIS PICTURE DOESN'T CAPTURE THE FUN OF A CARNIVAL.

Take a photo walk through a carnival at night. You're not there to go on the rides, you're there to photograph them. This is another place where amateurs can take pictures they thought were only in the realm of the professional. If you don't live in a town where the traveling carnival is a summer staple, the bright lights of a big city will do just as well. Turn off your flash and play. Experiment. You will amaze yourself.

A tripod would be a good idea, but you can get by without one if you lean your camera—not your body—against a solid object.

Here's what you will notice in the finished pictures: First of all, things will appear to be very bright—brighter than what you saw. The camera was collecting and storing light, something the human brain cannot do. Because your (automatic exposure system) is going to open the shutter for longer than normal periods of time, anything that moved will take on an unpredictable otherworldliness. That's why experimentation is the mode you need to be in. This is where the immediate feedback of a digital camera is so educating.

WHETHER IT'S TIMES SQUARE OR A COUNTY FAIR, ANY LOCATION THAT GLOWS AFTER DARK IS A GREAT SUBJECT THAT REQUIRES ONLY A LITTLE TECHNICAL EXPERTISE.

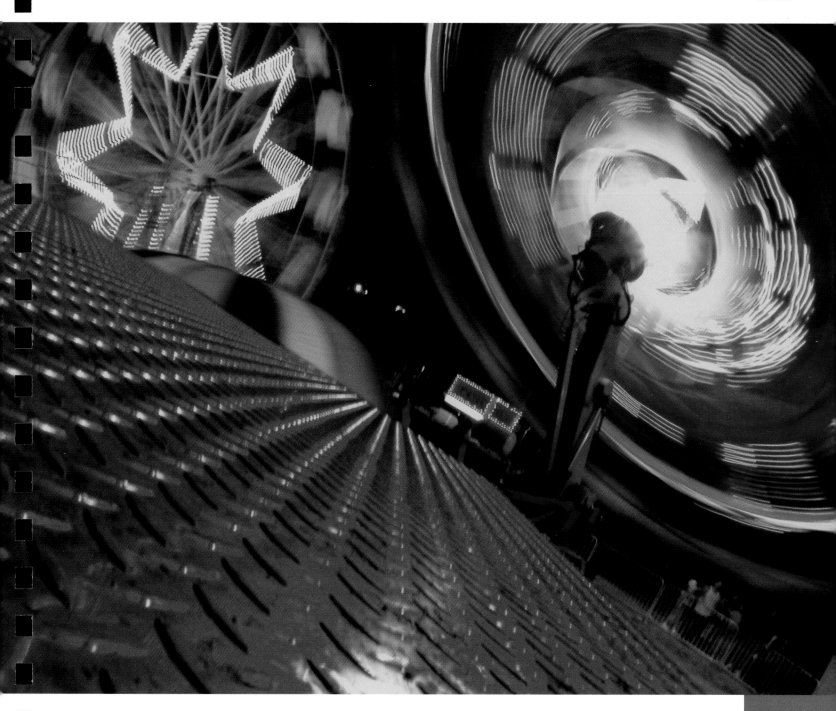

HOW TO PHOTOGRAPH
YOUR DOG

I was glad to have this chance to photograph my in-laws' black Lab, Sam I Am (that's what it says on his tag) shown on the opposite page. A few weeks earlier he had been mysteriously injured and was really hurting—the fact is, he almost died. Sam is young, and no one had ever taken a decent picture of him. Both of us were given a second chance and I took advantage of it.

A black furry mammal may very well be one of photography's greatest challenges. It doesn't reflect light, in fact, its body seems to absorb it. Recently I had an assignment to photograph a group of hospitalized children playing with a visiting dog. If Lassie had walked into the room there would have been a number of picture possibilities, but in came a large, black, long-haired dog—the Norwegian kind with hair covering his face. I was in trouble and the resulting pictures proved it. Most of them contained an amorphous black blob.

The secret to photographing a black dog, or most other dogs for that matter, is to separate the animal from the background—almost as a silhouette. There are a few ways to do this:

■ You can choose a plain background that contrasts with the dog.

■ You could use your lens at maximum zoom and try to get the background out of focus, again going for visual separation between the dog and the background.

■ You can choose a background that is much brighter than the dog (or darker if your dog is white) to achieve separation.

Your goal is always the same: Try to give the animal a clean simple shape by keeping the background plain and contrasting.

▼ I CALL THIS PHOTO "FIND THE DOG."

DO YOUR VERY BEST TO SILHOUETTE A DARK ANIMAL AGAINST A LIGHT BACK-GROUND. IT IS A CHALLENGE FOR EVEN THE VERY BEST PHOTOGRAPHERS. THE SAME RULES APPLY FOR AN OVERALL SHOT OF A DOG OR A SIMPLE HEAD SHOT.

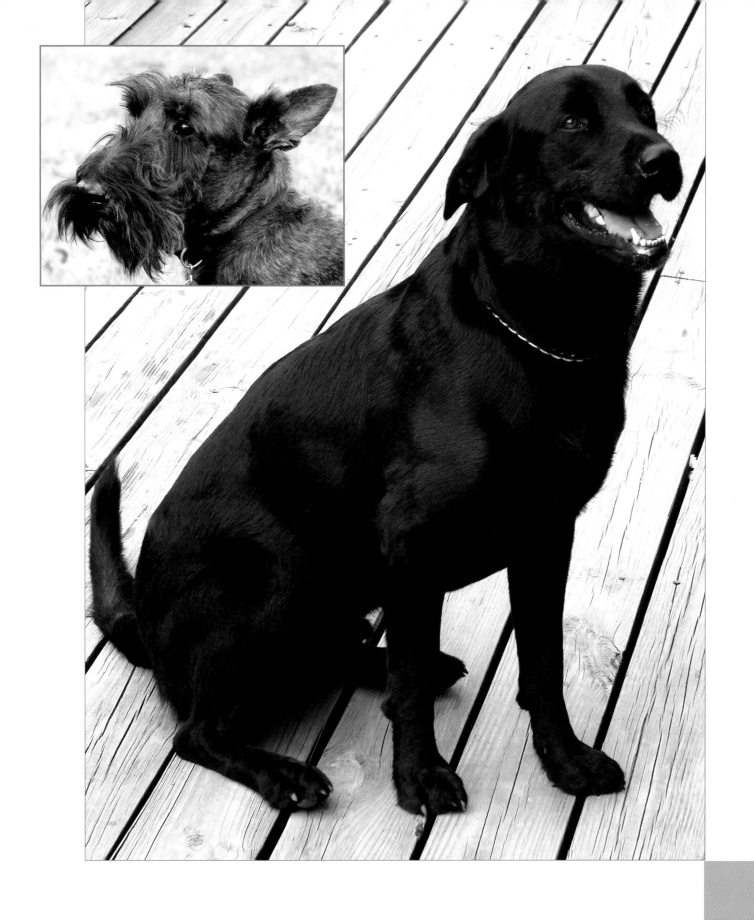

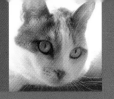

HOW TO PHOTOGRAPH
YOUR CAT
(DIFFERENT RULES APPLY)

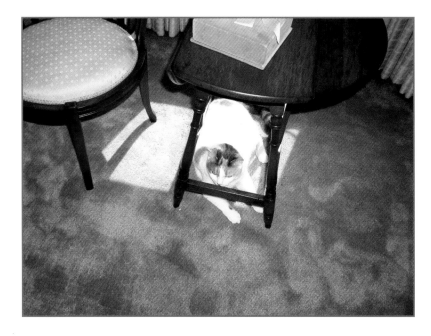

 VIRTUALLY ALL GOOD CAT PHOTOGRAPHS ARE CLOSE-UPS. FILL THE FRAME WITH YOUR CAT AND LEAVE OUT THE FURNITURE.

A great wildlife photographer told me that when he photographed animals he tried to think like the animal. When he spent a thousand hours in a tree house photographing parrots, for example, he became a parrot.

So, I say, when photographing a cat become a cat. Stalk. Study the places where they hang out. Learn their habits. Let them come to you and then pounce. They have been asking for it.

My research shows that virtually every cat that lives in a house will at some point gravitate toward the perfect photographic light source—a windowsill.

If you are trying to photograph your cat in a dark corner, you are probably shooting with a flash and that is a big mistake. Cats have a membrane that lines the back of their retinas and acts like a mirror. That's why cats' eyes appear to glow when bright light is shined in them. So unless you want your cat to look like a creature from another world, turn off your flash and take the picture when the cat is near a window.

BIDE YOUR TIME. THE CAT IN YOUR LIFE WILL SOONER OR LATER
WORK ITS WAY TO A WINDOW, WHICH IS A WONDERFUL LIGHT SOURCE.
A FLASH WOULD HAVE DESTROYED THE BEAUTY OF THIS PICTURE.

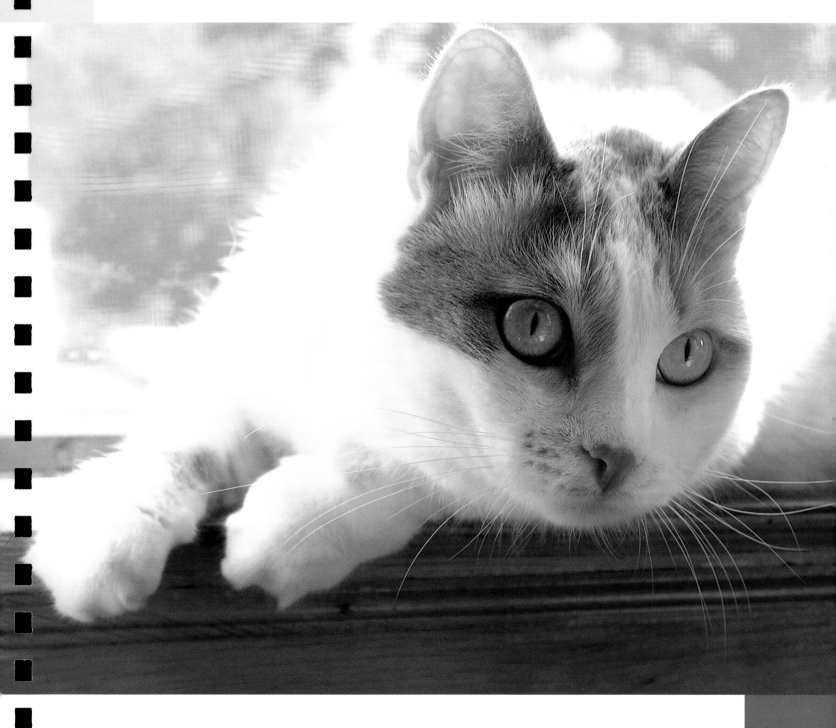

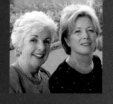

HOW TO PHOTOGRAPH
WOMEN,
MAKE THEM LOOK BEAUTIFUL, AND HAVE THEM LOVE THE PICTURE

This is my mother-in-law and her sisters (opposite). For a variety of reasons, not the least of which is the happiness of my marriage, it's important that they look good in this book and that they like this picture. I'm dying to tell you how old they are, but suffice to say, I'll be fifty this year and my wife is not inappropriately young.

I needed to capture the obvious beauty of these women. My assignment was easy: find soft light. Soft light means the direct rays of the sun are not hitting your subject. In this case, it was under the shade of a large open porch with a simple background.

Virtually everyone looks better in soft light. Harsh, direct sunlight makes sharp, well-defined shadows like the ones you see here under my father's glasses (below)—not great. Soft light, on the other hand, is flattering to everyone, not just mothers-in-law. Ninety-nine-point-nine percent of the photographs that have appeared on the cover of *Cosmopolitan* were taken in soft light and those were pictures of teenagers with $1,500-make-up jobs. I have taken pictures of movie stars in direct sunlight and, believe me, it's still an uphill battle.

It may take you a while to find the right location, so try to do that before you gather your subjects. And be prepared to stand on a stool, a chair, or even a top step—everyone looks better with their chin raised toward the camera, too.

I recently sent each of these women a copy of this picture. It was worth it.

 THERE ARE FEW PEOPLE IN THE WORLD WHO LOOK GOOD UNDER THE MIDDAY SUN.

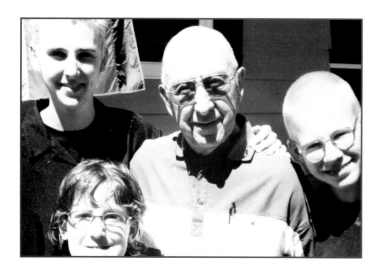

EVERYONE APPRECIATES THE
QUALITIES OF SOFT LIGHT,
WHETHER THEY KNOW IT OR NOT.

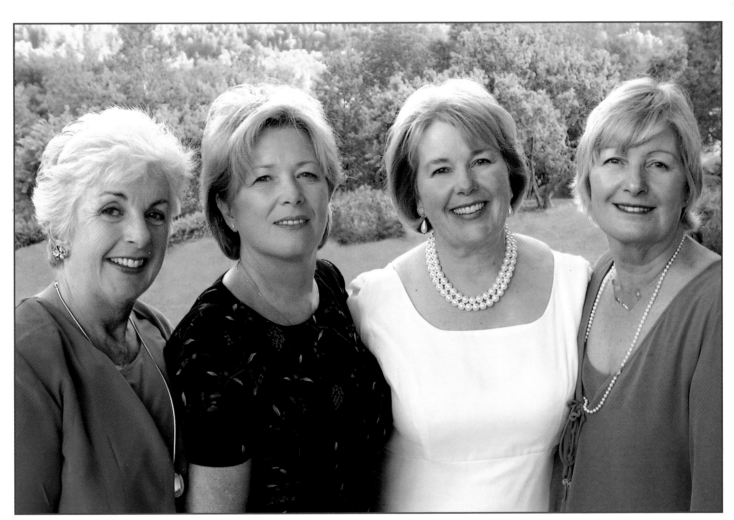

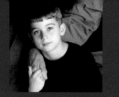

A GROUP
OF PEOPLE

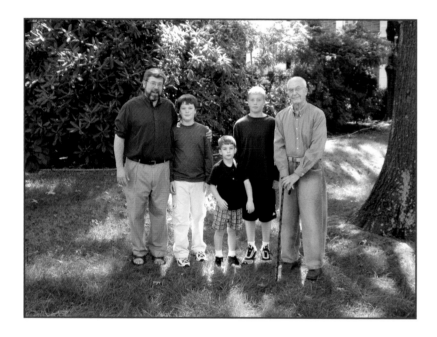

All rules are general, of course, but here's one for group shots that you could follow forever: Give as much space as possible to faces in your group shots and as little as possible to legs and feet.

Make that your mission statement the next time you are the designated group-shot photographer. It will help you pose the group quickly and shoot the picture more efficiently. After you've done this a few times your group shots will be better in half the time.

 TRY TO AVOID THE LOOK OF A POLICE LINEUP. THERE ARE SO MANY OTHER OPTIONS.

DO YOUR VERY BEST TO GET PEOPLE'S HEADS AS CLOSE TOGETHER AS POSSIBLE AND FORGET ABOUT THEIR LEGS. IT WILL MAKE ALL THE DIFFERENCE.

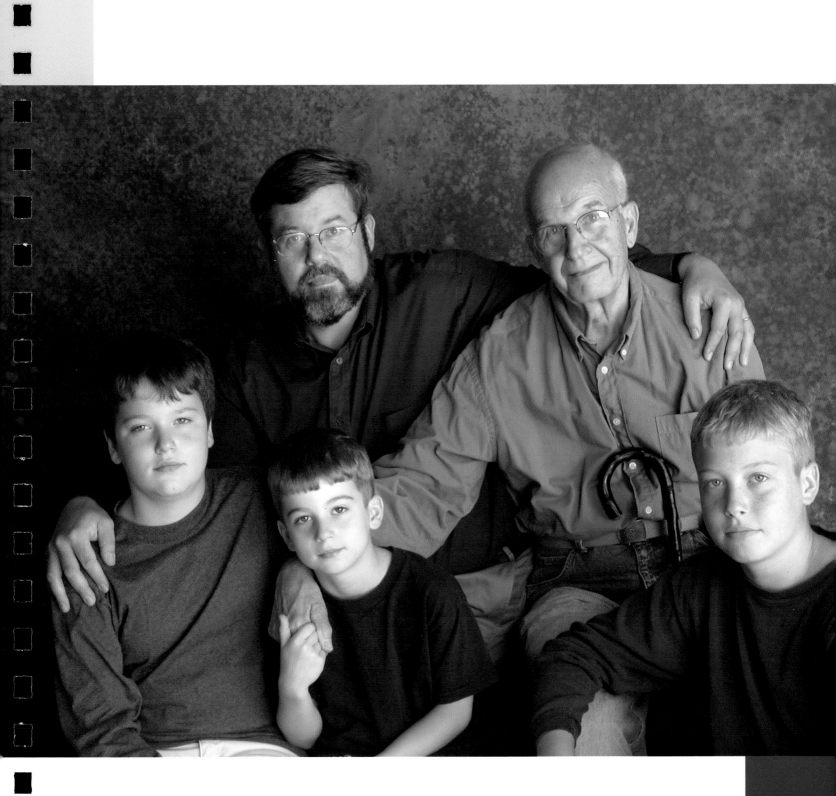

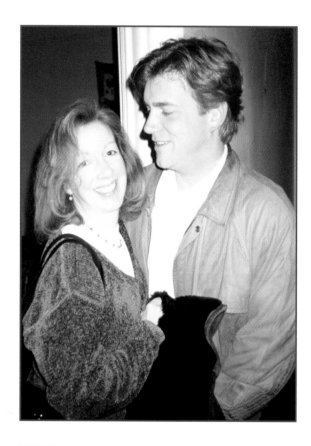

 THE PRESENCE OF A PHOTOGRAPHER OBVIOUSLY INTERRUPTED A CANDID MOMENT.

Our daily lives are a series of spontaneous moments that we never consider photographing. Maybe this is because we don't know where the camera is, or maybe we just never thought of photographing spontaneous moments.

For example, how many people grab their cameras to capture a public display of affection? Just about none. But there are professionals who have built careers around moments just like the one on the opposite page. Modern technology allows us to carry a camera as easily as a pair of reading glasses or a cell phone and access is 90 percent of the battle.

Train yourself to think like this: "Hey, that looks special, or unusual, or like something I've never seen before, or . . ." Now stop thinking, grab the camera, and start pushing the button. *Stop thinking and start pushing the button.* Push the button to see what you will get. If you are wondering why you are taking this picture, you are thinking like an amateur.

Good photographers have learned that you need to push now and ask later. If you are pushing the button, despite the fact that it makes you feel a little uneasy, you may not be at the head of the class, but you're a contender.

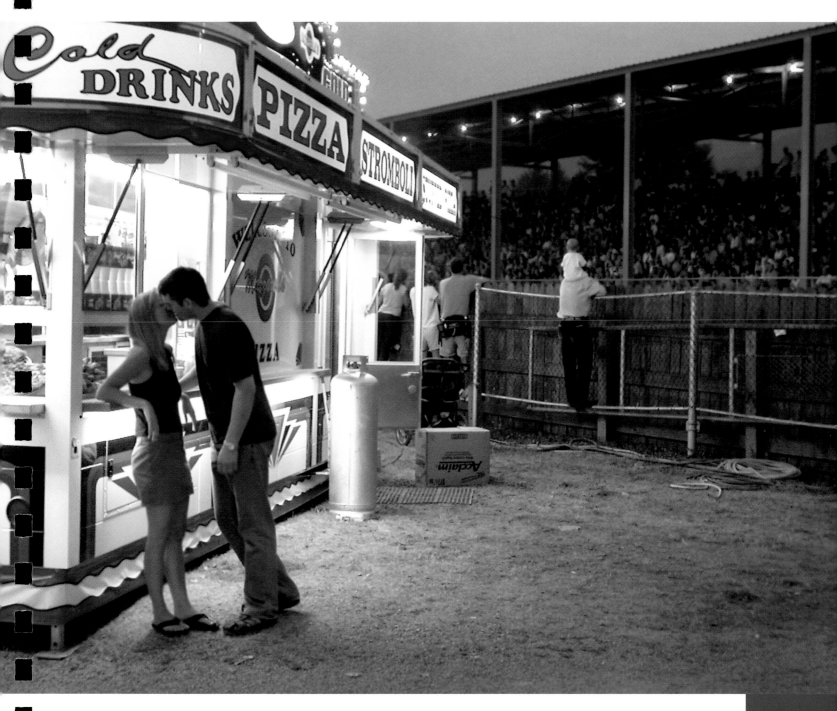

SOMETIMES KEEPING YOUR DISTANCE AND WAITING FOR THE RIGHT MOMENT IS FAR BETTER THAN TELLING YOUR SUBJECTS, "LOOK HERE."

HOW TO PHOTOGRAPH

A COUPLE

At its best photography communicates without words. The simple act of posing two people with their heads together when they are being photographed completely changes what a photograph communicates. It makes love a visual entity.

It does require you to direct your subjects, something you may never have done before. But pictures like this don't just happen. People need to be coaxed. I often gently nudge their heads together and before they have a chance to say something like, "This is silly," I will say something like, "This is going to feel silly, but it's going to look great through the camera." And it does.

I can't tell you the number of times those people who felt a little silly while posing, completely got the idea when they saw the picture.

I'm also not big on asking people to flash me with the biggest smile they can muster, either. A natural smile is wonderful, but there's no reason to force it. I think a pleasantly serious expression could also reinforce what you're trying to say about two people, which is simply that they love each other. Being a little serious is so much easier for the subject, too, instead of having to muster an artificial grin.

This pose not only works for couples, but friends, parents and children, and siblings, as well.

TWO PEOPLE PUTTING THEIR ARMS AROUND EACH OTHER CAN TRANSFORM A MUNDANE SNAPSHOT INTO A STATEMENT OF LOVE.

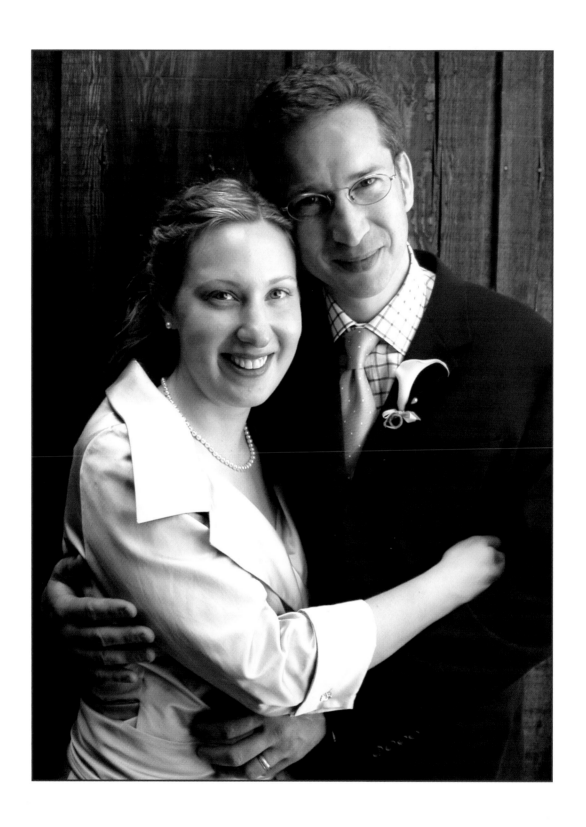

HOW TO PHOTOGRAPH
A BABY'S FACE

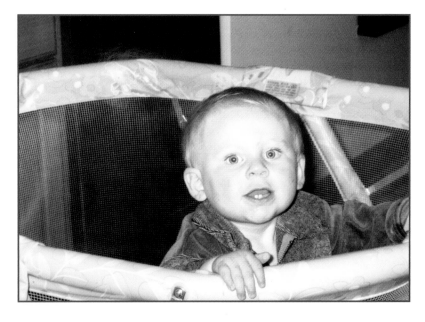

This is an example of having patience and working your magic when the moment happens. You can frustrate yourself to no end by trying to get a baby to appreciate your desire to photographically record his or her wonderfulness. That is a dead-end street.

But when the baby is lost in his or her babyness, you can hardly miss. Keep pushing the button. You will get countless good photos. So many, in fact, that you won't be able to pick a good one. The trick is to take your time and go into action when the show starts.

▲ THE STANDARD APPROACH: AUTO FOCUS, AUTO EXPOSURE, WITH LITTLE REGARD FOR EVERYTHING IN THE FRAME.

WHEN GOOD THINGS ARE HAPPENING IN FRONT OF YOUR CAMERA, KEEP PUSHING THE BUTTON.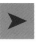

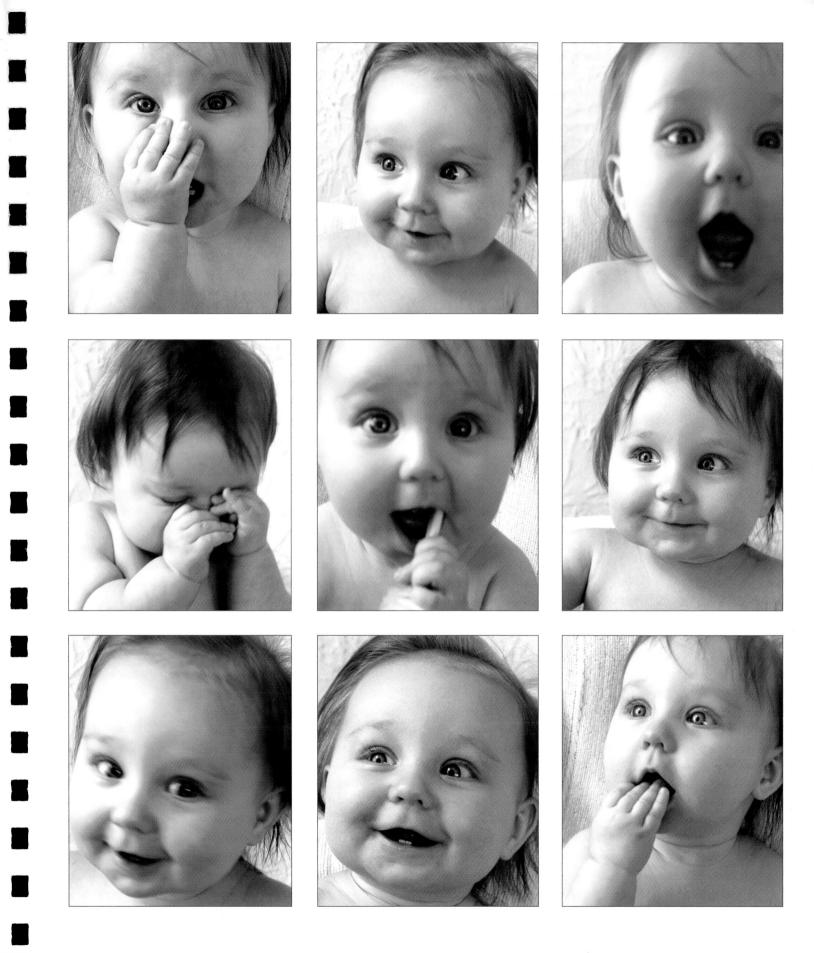

 ANOTHER STANDARD FLASH SNAPSHOT THAT LACKS THE POIGNANCY OF A WELL-LIT CLOSE-UP.

Despite the fact that books and magazines and movies are full of pictures to the contrary, amateur photographers believe it's a bad idea to cut off the top of someone's head.

In Hollywood, the shot you see opposite is called an extreme close-up. Good directors use it with discretion because they understand that for human beings a close look at one of their own is as powerful as it gets.

As soon as you fill your frame with nothing but face, you've broken through a psychological barrier. You have stepped into a place where thoughts are shared. You have become intimate in the time it takes to turn a page. Putting the face slightly off center also adds another level of positive visual tension that is difficult to explain yet easy to understand when you see it.

It is okay to cut the tops of heads off sometimes—not all the time; in fact, not most of the time. But do shoot extreme close-ups thoughtfully. It is one of a professional's most effective tools.

IRONICALLY, NO SUBJECT BEGS TO HAVE THE FLASH TURNED OFF MORE THAN THE HUMAN FACE. THE USE OF NATURAL LIGHT, BLACK-AND-WHITE, AND DRAMATIC FRAMING ALL DRAW ATTENTION TO THE BEAUTIFUL CONTOURS AND SHADING THAT GIVE A FACE EXPRESSION.

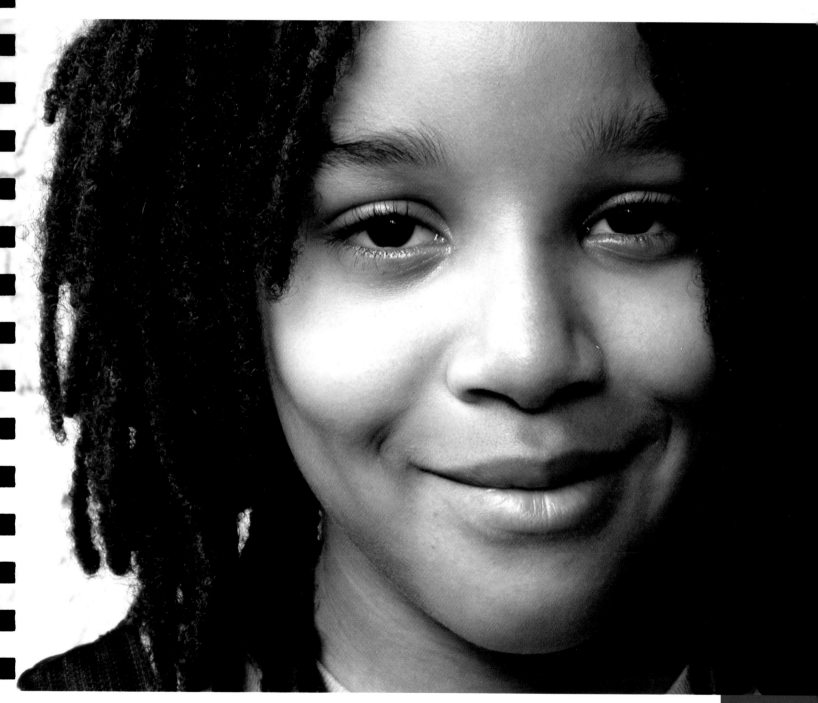

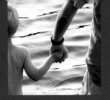

PORTRAITS
WITHOUT FACES

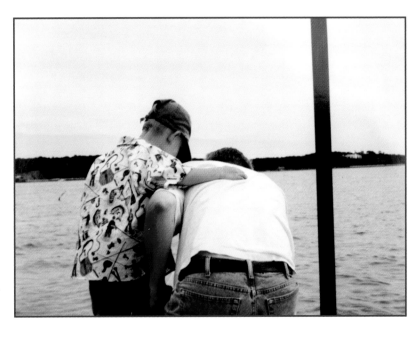

 SHOOTING FROM BEHIND IS USUALLY NOT THE ANSWER. THE BODY LANGUAGE HAS TO WORK FOR THE PHOTO TO SUCCEED.

Amateurs blindly believe that before a good photograph can be taken, the photographer first has to say something like, "Hey everybody, look here."

All day, every day, wonderful, emotional events happen in front of us. And sometimes the fact that our subjects' backs are to us is not a negative but a plus. Body language can be so telling. The mystery of not seeing a face can actually add appeal to a photograph. It makes us wonder what the subjects are feeling or thinking.

There's also the obvious but almost subconscious fact that someone else was present—the photographer—possibly unknown to the subjects.

Sometimes a back view says more. I don't think an amateur photographer has ever proudly shown me a picture of someone's back. It's professional thinking.

I LOVE THE FACT THAT LITTLE NAKED NICHOLAS APPEARS TO BE MARCHING BRAVELY INTO THE FUTURE WITH HELP FROM HIS SEASONED TEENAGE COUSIN.

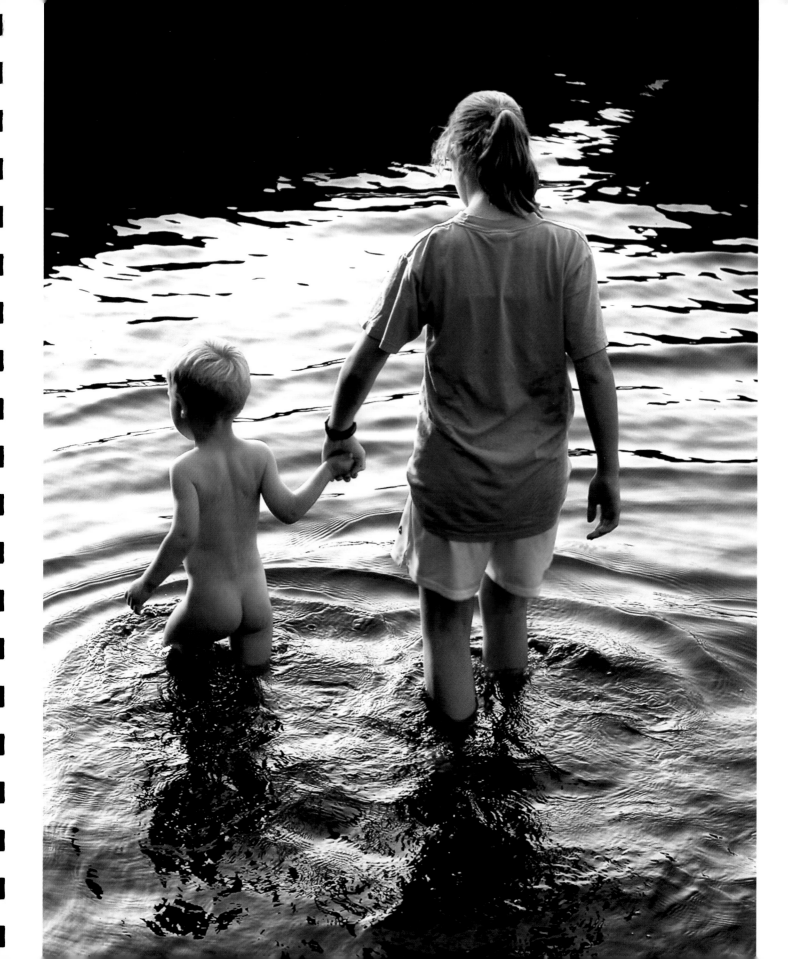

A PORTRAIT WITHOUT A PERSON

 MY FRIEND GREG LIKES
TO DO THE *NEW YORK TIMES*
CROSSWORD PUZZLE. THIS
PICTURE FAILS TO MAKE
THE POINT.

This is one of the classic assignments in basic photography classes. And it's a great idea: Take a picture of someone without the person being in the picture.

That is, find a scene or an object that exemplifies the person. What I like about this is that it opens your eyes to a much bigger world of photographic possibilities. The picture could be a wall covered with awards or a pile of laundry, but imagine how touched you would be if someone photographed your workbench or your bag of knitting just because it makes them think of you.

A scene that contains many objects is a great opportunity for an unusual composition. You don't have to show all of everything—significant objects partially cropped off at the edges of the frame will strengthen your picture in the process. A picture of a dirty coat hanging on a hook above a pair of muddy boots does not have to be an overall shot of the wall. A close-up of the boots with the bottom of the coat coming into the frame can have as much, or more, impact.

GREG'S GLASSES, PEN,
AND HANDWRITING TURN THIS
PICTURE INTO A UNIQUE AND
PERSONAL STATEMENT.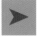

HOW TO PHOTOGRAPH

A PORTRAIT BY CANDLELIGHT

 FLASH PHOTOGRAPHY AND LOVING FEELINGS ARE PRACTICALLY INCOMPATIBLE.

Candlelight is another example of light that makes people look good. It's also another example of light that scares amateurs away. Everyone knows you can't take pictures in candlelight, right? Wrong. You can take pictures by the light of a match if you know what you're doing.

You need a tripod—candlelight is really dim. The shutter speed for this picture was about one-half second—much longer than you could hold a camera still. Your subjects need to hold as still as possible, too. And you need to take a lot of pictures because although your camera is on a tripod, your subject will move slightly in most of the pictures. Even a breath at the wrong moment can produce a blurred image. There will be lots of mistakes on both sides of the camera. But if you take a picture you like in candlelight, your confidence will soar and you will be a better photographer.

This is my friend Lia. She asked me to take a picture of her to send to her husband on their first wedding anniversary. His National Guard troop had been called up unexpectedly and he spent the anniversary in Bosnia. I though candlelight was the perfect solution despite its technical challenges.

ROMANCE NEEDS MOOD LIGHTING
AND CANDLES ARE PERFECT.

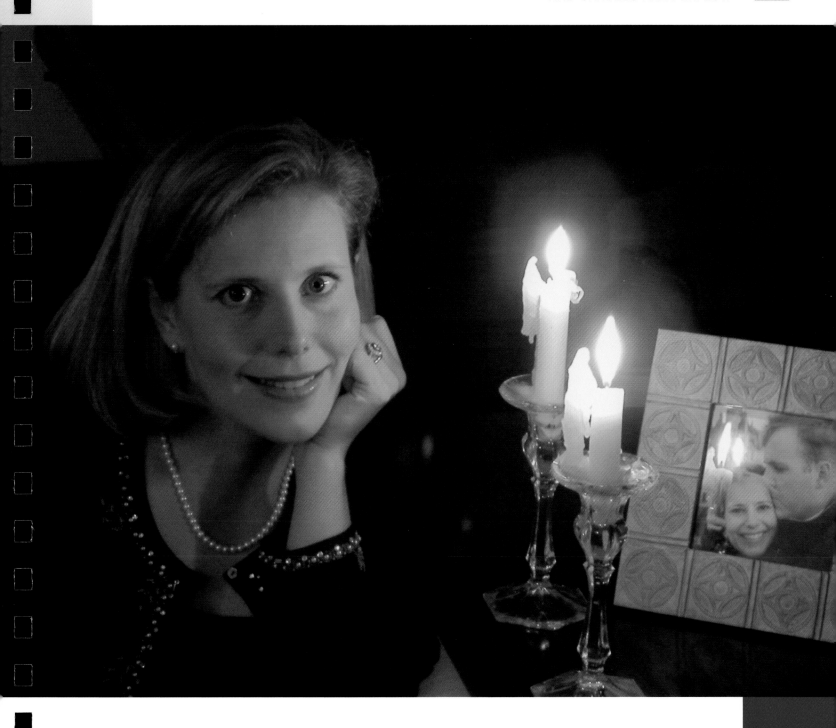

HOW TO TAKE A PICTURE

FOR A PERSONAL AD

 THIS BUSY BACKGROUND
AND HORIZONTAL FRAME SAY
NOTHING ABOUT JEROME.

This is my business partner, Jerome. One day he sheep-ishly, almost pathetically, came to me and whispered, "I'm finally going to do it. Will you take a picture of me for a personal ad?"

"Jerome," I said, "This is your lucky day. Your ad just went from being an obscure Internet blip to a full-page color photo in a published book. Congratulations." He feigned shock, but as he walked away the pep in his step indicated elation.

I recently read that 90 percent of people who get dates over the Internet felt deceived by the photograph. Deception seems like an awkward first step for any relationship, so to put yourself in that rock-solid 10 percent you need to be blatantly, perhaps painfully honest. A full-length shot is very telling. For one thing, it says you are brave.

Jerome is a brave heterosexual.

If interested, please contact
jerome@nickkelshmatchmaking.com.

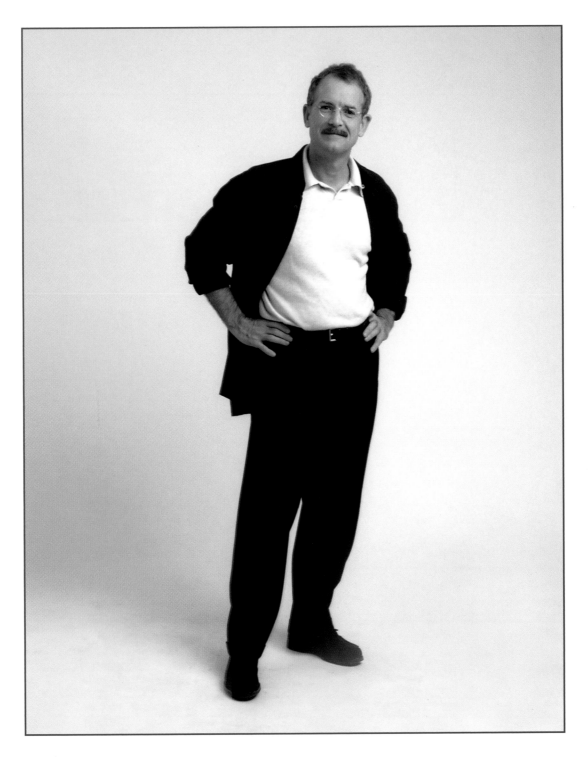

 SIMPLICITY, HONESTY, AND A WELL-EXECUTED PHOTOGRAPH
MAKE A WONDERFUL FIRST IMPRESSION.

I think any successful photo on eBay does the following:

■ It shows the object clearly and honestly and yet makes it as appealing as possible.

■ It shows the object from more than one angle, which almost always requires more than one picture (I say almost always because you could display an item in front of an angled mirror and get two views at once).

THIS PICTURE IS JUST TOO COMPLICATED. IT'S DIFFICULT FOR A POTENTIAL BUYER TO REALLY SEE WHAT IT IS YOU'RE TRYING TO SELL.

The presentation of the photos themselves provides the viewer with an idea of how careful, caring, and, well, compulsive the seller is. When I shop on eBay I hope the seller is careful, caring, and compulsive—in a good way.

I took the pictures at right on a curved piece of white poster board on my dining room table under the two light fixtures that hang above it and stretched a string to stand them upright. I saw dozens of photographs on eBay that looked like the bad example below—objects photographed in a pile, making it difficult to see what was for sale. The plainer and simpler the background, the better.

Of course, you're always taking a chance. You might think that presenting dolls in this state of undress opens you up to criticism of all sorts. Go to the eBay site. People want to see what they are buying.

I guess the bottom line is, conceal nothing.

MY WIFE AND I WERE HOPING THAT HUMOR AND VISUAL SIMPLICITY WOULD SELL HER DOLL COLLECTION. WHEN SHE SAW THE PHOTOS, SENTIMENTALITY TOOK OVER AND SHE DECIDED TO KEEP THEM.

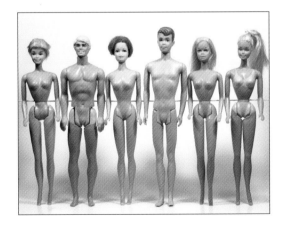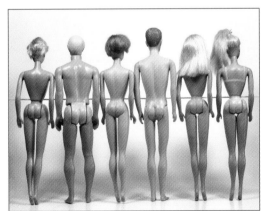

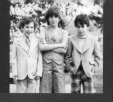

HOW TO PHOTOGRAPH

THE PASSAGE OF TIME

There are all kinds of subjects you can photograph that will capture the passage of time—from before-and-after house renovations to pictures of your garden over the course of a summer—but there is no more poignant record of time passing than pictures of kids growing up.

My friend Alan Molod took these pictures of his children as they passed into adulthood and two little brothers became two big brothers. At first glance, the pictures appear to be average amateur snapshots, but consider all of the things that Alan did right.

■ The kids are always in the same order from left to right and are always seen full length. This is no accident; by the way, Alan is one of the few amateurs I've ever met who shoots lots of close-ups.

■ The kids are always roughly the same size in the frame—actually, as they get older they fill the frame a little more.

■ The location is the same and, for the most part, so is the time of the year—the cherry tree is blooming.

As the kids became older and moved to other parts of the country and the world, it became more difficult to keep the visual elements consistent—the location changes in some of his later pictures, but the emotional impact of his finished product was not compromised.

If you took a picture of your child's face every day for, let's say, fifty years, and put all 18,262 pictures on a piece of movie film, you would certainly make photo history. If you find that prospect overwhelming, think of a way to photograph someone once a year. In a surprisingly short number of years you will have a powerful collection of pictures.

WHEN DOCUMENTING THE GROWTH
OF CHILDREN, PICK A LANDMARK AS
A LOCATION—A TREE, A ROCK, A
MONUMENT—SOMETHING THAT ISN'T
GOING TO GO AWAY ANYTIME SOON.

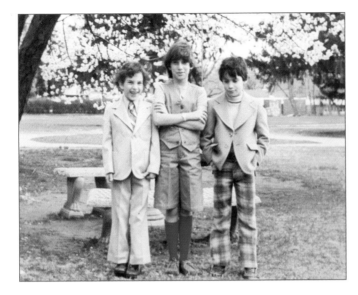

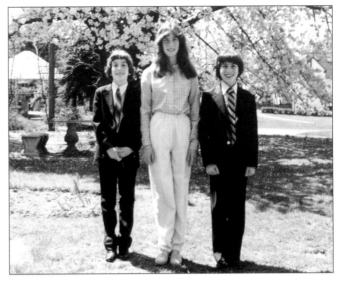

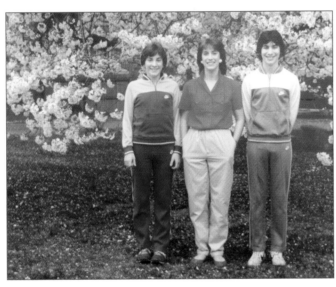

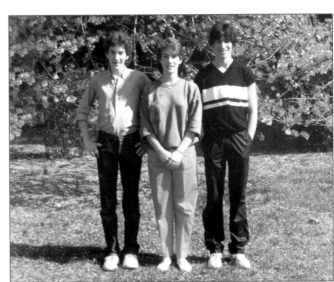

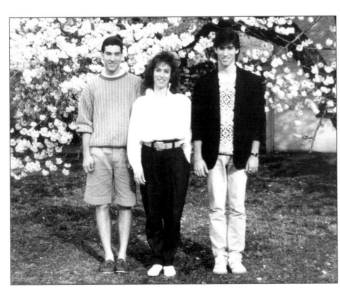

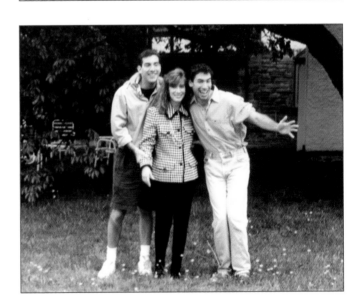

HOW TO MAKE
A GIFT OF PHOTOGRAPHY

You could solve every gift-giving problem you will ever have with a camera: Think of someone you love, ask yourself what they would like a photograph of, and take the picture.

Here's the twist. Photograph something they would never, ever, think of wanting a picture of—but that you know they will like a picture of. Suddenly, you have tapped into an emotional well that, in the end, will leave you feeling better than the recipient of the gift—and they will be feeling pretty good.

The camera is a tool. There are saws and sewing machines and toothbrushes and light-sensitive image recording devices. It is a means to an end. You can make things for people with a camera.

My friend, Jim Richardson (not the great *National Geographic* photographer, but another great photographer who mentors 4-H photographers in the Catskill Mountains) learned that his wife's childhood vacation cottage was being demolished. He retrieved an oceanside window frame from the junkman, photographed the cottage's original ocean view, put prints of the view in the window frame, and gave it to her for her birthday.

Jim Richardson loves his wife. Her name is Joanna.

IN CREATIVE HANDS THE CAMERA IS
A TOOL THAT CAN TOUCH THE HEART.

Nobody's behind the camera that took this photograph. It's sitting on a tripod and I'm triggering the shutter with the remote transmitter hidden in my left hand.

This is Madrid, Spain. I was sent here by a client a couple of weeks before my book deadline and needed to get some work done. I'd like you to believe that I'm writing the words you are now reading, but to be perfectly honest, I'm watching out of the corner of my eye for a red bus to pass by to give this picture a spot of color and a European feel.

The self-timer or a remote shutter button offers great opportunity for play. And so here is a picture of me playing. And that's the image I'd like to leave you with. Play. Just have fun. Keep pushing the button. If it doesn't hurt too much, think a little. If it does hurt too much, stop thinking. But keep playing because playing with a camera will keep your photography alive.

It goes something like this: Play. Play. Play. Delete. Play. Delete. Wish eternal hellfire upon the author or your instruction manual. Play. Think. Stop thinking. Delete. Play. Delete. Play. Cry a little because you love that picture so much. Play. Delete. Share your pictures. Delete. Play

Celebrate.

I love photography.